the
best
of
business
card design

GLOUCESTER MASSACHUSETTS

ROCKPORT
PUBLISHERS

CHERYL DANGEL CULLEN

First published in the United States
of America by:

Rockport Publishers, Inc.
33 Commercial Street
Gloucester, Massachusetts 01930-5089
Telephone: (978) 282-9590
Fax: (978) 283-2742
www.rockpub.com

ISBN 1-56496-750-6

10 9 8 7 6 5 4 3 2 1

Cover Design: Matter
Interior Design: Stoltze Design
Interior Layout: Elisabeth Gerber

Printed in China

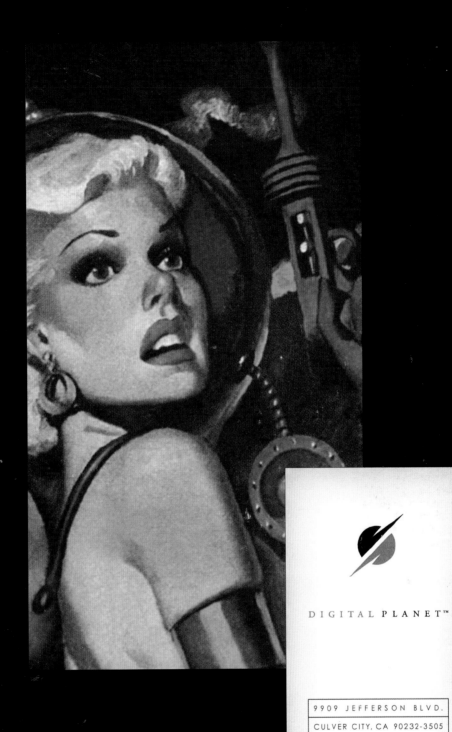

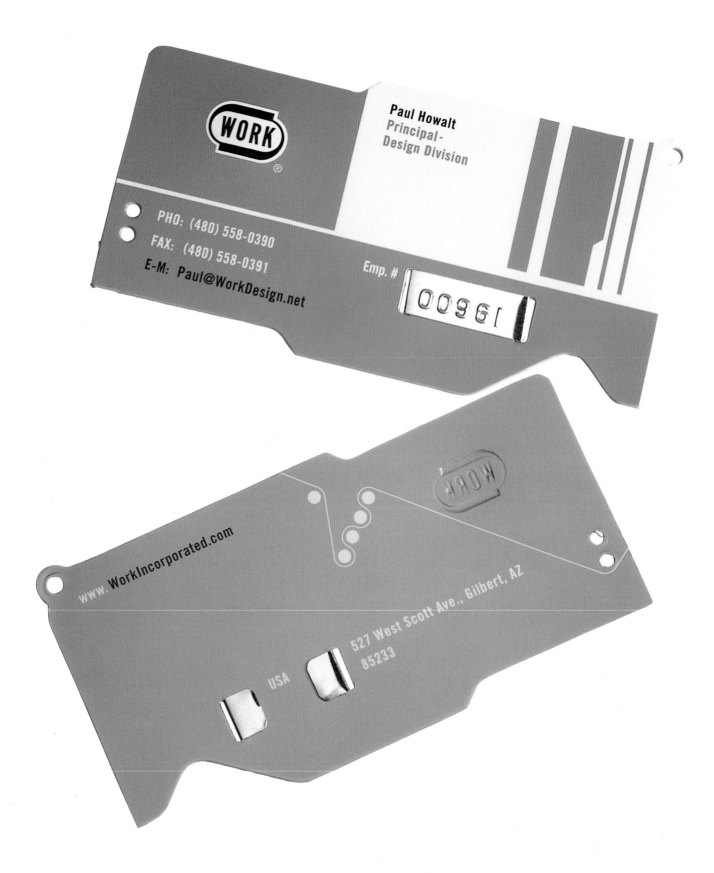

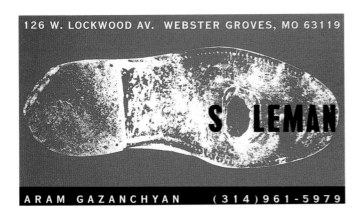

126 W. LOCKWOOD AV. WEBSTER GROVES, MO 63119

S LEMAN

ARAM GAZANCHYAN (314)961-5979

Introduction

The unassuming business card is demanding more and more attention these days. Once, they served a purely perfunctory purpose—leave behind contact information for later retrieval. They were just that—business cards—and they were all business. Today, their primary purpose is still to communicate information, but at the same time, they are increasingly used as sales tools and more often than not, create that all-important first impression in the mind of the recipient. Today's business cards get down to business but do it with flair, panache, and a touch of whimsy.

Throwaway business cards with the basic name, title, company address, and telephone are a rare find these days. Cards that are keepers are those that not only contain all the usual information—a logo, fax, email address, Web site, and cell phone number—but are memorable as well—a tall order for so small a canvas.

So how are designers managing? Designers are discarding all the rules they ever learned about business cards. Total freeform, creativity is evident among the very best designs.

Cards are two-sided; why waste a perfectly good side when selling is on the line? Color is everywhere with some cards, literally exploding with a rainbow of hues, while others make use of four-color process as if they were high-end brochures. Interactive cards that engage the recipient, asking them to open, untuck, fold, or otherwise manipulate the card to appreciate its full message are common. Die-cuts are another phenomenon of the early twenty-first

century, occurring almost as often as one sees a Web site address on a card.

Cards, too, are often a reflection of the owner; individuals are designing their own cards and choosing their own color palettes, while some feature caricatures of the owner or sport a tagline that is particularly apropos to his or her specialty. Size is no longer set in stone, either. While the majority of business cards still stick to the traditional 2 x 3-1/2 inches (6 x 9 cm), others show total disregard for strict dimensions in favor of circular shapes, long, narrow formats or large, oversized canvases.

And that's just the beginning.

Cards are innovative, spontaneous, succinct, and provocative. Designers scratching their heads in desperate search of inspiration are sure to find plenty of ideas in *The Best of Business Card Design 5*. What are the trends in business cards for the twenty-first century? Browse through these pages to see for yourself that the only trend is design what you like and like what you design.

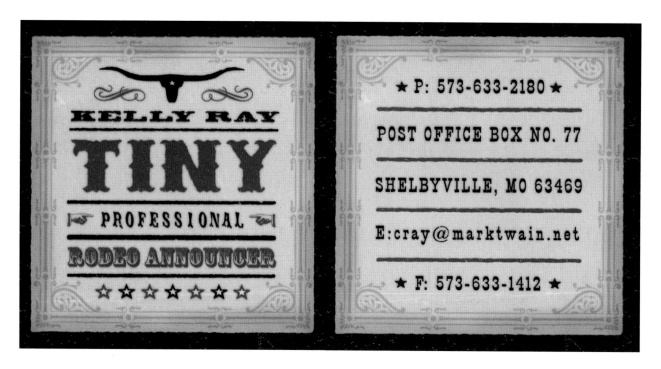

CLIENT: Tiny Ray

DESIGN FIRM: Gardner Design

ART DIRECTOR/DESIGNER: Travis Brown

SOFTWARE: Macromedia Freehand

CLIENT: Piscatello Design Centre

DESIGN FIRM: Piscatello Design Centre

DESIGNER: Rocco Piscatello

SOFTWARE: Quark Xpress

PAPER STOCK: Potlach Silk Bright White / 120lb.

PRINTING: Continental Anchor

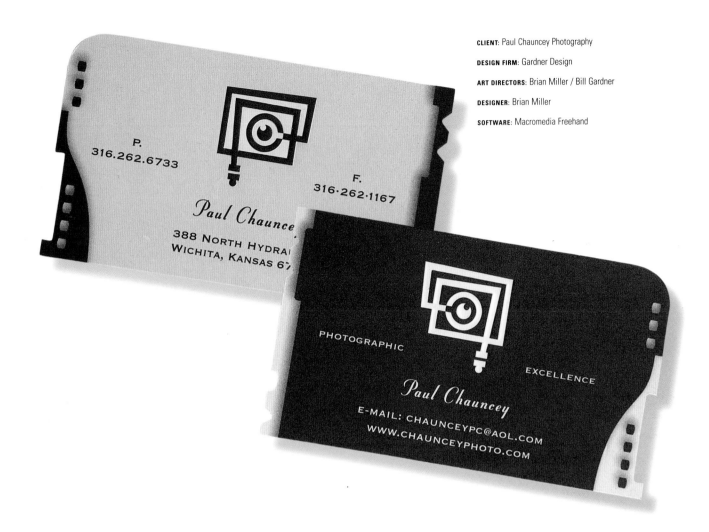

CLIENT: Paul Chauncey Photography

DESIGN FIRM: Gardner Design

ART DIRECTORS: Brian Miller / Bill Gardner

DESIGNER: Brian Miller

SOFTWARE: Macromedia Freehand

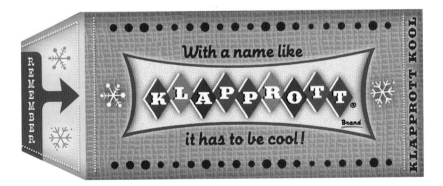

CLIENT: Klapprott

DESIGN FIRM: Gardner Design

ART DIRECTOR/DESIGNER: Brian Miller

SOFTWARE: Macromedia Freehand

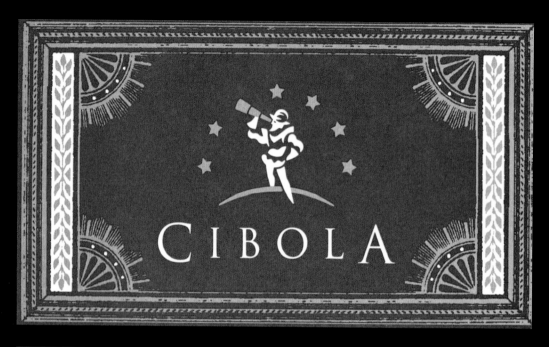

CLIENT: Cibola

DESIGN FIRM: Gardner Design

ART DIRECTOR/DESIGNER: Chris Parks

SOFTWARE: Macromedia Freehand

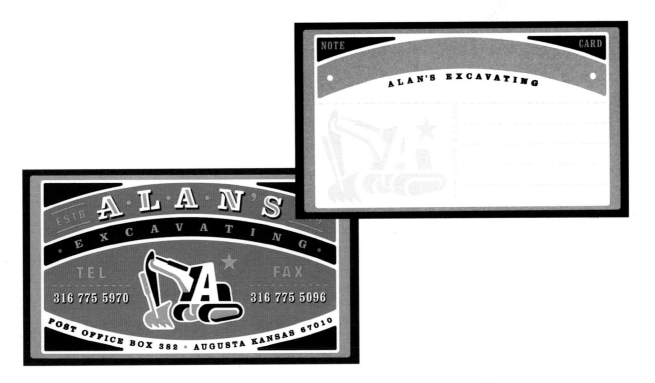

CLIENT: Alan's Excavating

DESIGN FIRM: Gardner Design

ART DIRECTOR/DESIGNER: Chris Parks

SOFTWARE: Macromedia Freehand

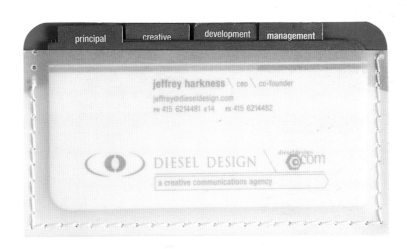

CLIENT: Diesel Design

DESIGN FIRM: Diesel Design

ART DIRECTOR/DESIGNER: Shane Kendrick

SOFTWARE: Adobe Illustrator

PAPER STOCK: Classic Crest Super Smooth
Solar White 130 lb.

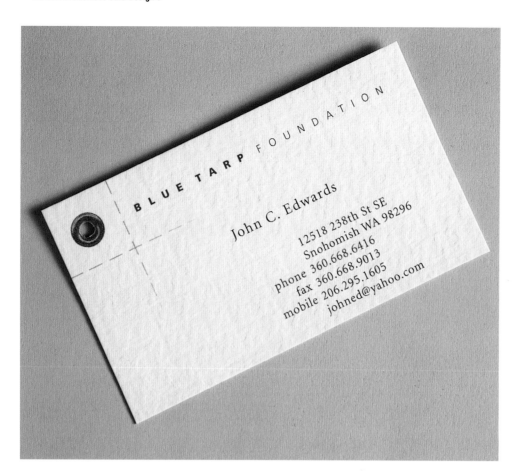

CLIENT: Blue Tarp

DESIGN FIRM: Design Duo Inc.

ART DIRECTOR/DESIGNER: Karla Chin

SOFTWARE: Macromedia Freehand / Adobe Photoshop

PAPER STOCK: Gilbert Esse White / 80 lb. cover

PRINTING: 2 PMS colors / drilled

CLIENT: ReelWorld

DESIGN FIRM: Design Duo Inc.

ART DIRECTOR/DESIGNER: Karla Chin

SOFTWARE: Macromedia Freehand

PAPER STOCK: Starwhite Vicksburg / Tiara Hi-Tech Cover Plus 88 lb.

PRINTING: 3 PMS colors / letterpress

Michael Berlin
Managing Director

503 Lenora Street
Seattle WA 98121
T 206.448.1518
F 206.448.1769

michael@reelworld.com • www.reelworld.com

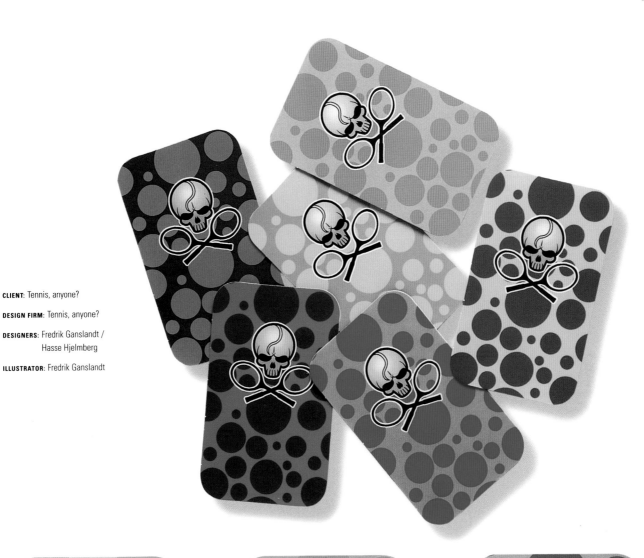

CLIENT: Tennis, anyone?

DESIGN FIRM: Tennis, anyone?

DESIGNERS: Fredrik Ganslandt /
Hasse Hjelmberg

ILLUSTRATOR: Fredrik Ganslandt

𝒯ennis, anyone ?

ULRIKA HOFFMAN · PROJEKTLEDARE

Gatuadress: Viktoriagatan 3

Postadress: 411 25 Göteborg

Telefon, växel: 031 10 60 60

Telefon, mobil: . . . 0703 59 18 88

Fax: 031 10 60 70

E-mail: . . . ulrika@tennisanyone.se

www: tennisanyone.se

SCRATCH´N´SNIFF
THE OFFICIAL SCENT

𝒯ennis, anyone ?

ULRIKA HOFFMAN · PROJEKTLEDARE

Gatuadress: Viktoriagatan 3

Postadress: 411 25 Göteborg

Telefon, växel: 031 10 60 60

Telefon, mobil: . . . 0703 59 18 88

Fax: 031 10 60 70

E-mail: . . . ulrika@tennisanyone.se

www: tennisanyone.se

SCRATCH´N´SNIFF
THE OFFICIAL SCENT

𝒯ennis, anyone ?

ULRIKA HOFFMAN · PROJEKTLEDARE

Gatuadress: Viktoriagatan 3

Postadress: 411 25 Göteborg

Telefon, växel: 031 10 60 60

Telefon, mobil: . . . 0703 59 18 88

Fax: 031 10 60 70

E-mail: . . . ulrika@tennisanyone.se

www: tennisanyone.se

SCRATCH´N´SNIFF
THE OFFICIAL SCENT

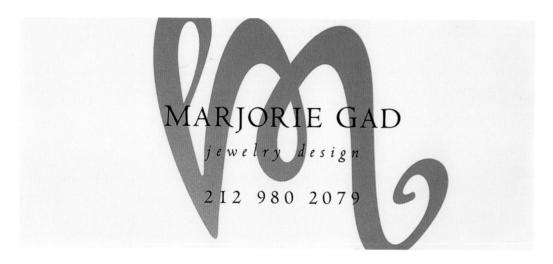

CLIENT: Marjorie Gad Jewelry

DESIGN FIRM: i.e. design, inc.

ART DIRECTOR: Bethlyn B. Krakauer

DESIGNER: Lee Lipscomb

SOFTWARE: Quark XPress / Adobe Illustrator

PRINTING: Black and metallic ink / offset

Rob Mangano r.mangano@berwynny.com

350 Hudson Street New York, NY 10014 v 212.519.3862 f 212.519.3790

CLIENT: Berwyn Editorial

DESIGN FIRM: i.e. design, inc.

ART DIRECTOR: Bethlyn B. Krakauer

DESIGNER: Lee Lipscomb

PHOTOGRAPHER: Leslie Dumke

SOFTWARE: Quark / Adobe Photoshop

PAPER STOCK: Starwhite Vicksburg

PRINTING: 4 over 2 / offset

CLIENT: Eyecandytv.com

DESIGN FIRM: Blok Design

ART DIRECTOR: Vanessa Eckstein

DESIGNERS: Vanessa Eckstein / Frances Chen

SOFTWARE: Adobe Illustrator

PAPER STOCK: Cromatica

EYECANDYTV.COM
POB 668/41 INDUSTRIAL RD. UNIT 1
WAINSCOTT, NEW YORK 11975 USA
T/631 537 4650 F/631 537 4648

CLIENT: Bandolero Films

DESIGN FIRM: Blok Design

ART DIRECTOR/DESIGNER: Vanessa Eckstein

SOFTWARE: Adobe Illustrator

PAPER STOCK: Strathmore

PRINTING: Offset

bedlam films

bedlam films

53 ONTARIO ST. TORONTO ON CANADA M5A 2V1 **T** 416 214 4525 **F** 416 869 1737

BEDLAM FILMS

CLIENT: Bedlam Films

DESIGN FIRM: Blok Design

ART DIRECTOR: Vanessa Eckstein

DESIGNER: Stephanie Yung

SOFTWARE: Adobe Illustrator

PAPER STOCK: Strathmore

PRINTING: Offset

CLIENT: GraphicType Services

DESIGN FIRM: GraphicType Services

ART DIRECTOR: John V. Cinquino

DESIGNER: Carl V. Horosz

SOFTWARE: Adobe Pagemaker

PAPER STOCK: French Speckletone Kraft

PRINTING: 2 over 1 / spot / offset

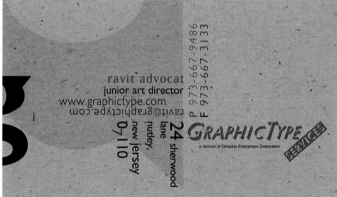

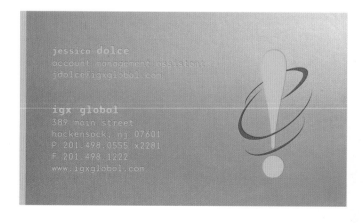

CLIENT: IGX Global

DESIGN FIRM: GraphicType Services

ART DIRECTORS: John V. Cinquino / Ravit Advocat

SOFTWARE: Adobe Pagemaker / Adobe Illustrator

PAPER STOCK: Coated 80 lb. cover

PRINTING: 4 over 5 plus silver and varnish

curious paper collection

CLIENT: Dixler Studio

DESIGN FIRM: Smith Design Associates

ART DIRECTOR: James C. Smith

ILLUSTRATOR: Debby Dixler

SOFTWARE: Adobe Illustrator

PAPER STOCK: Card stock

PRINTING: Litho

Michael H. Carlisle | Sales Director – North America
Arjo Wiggins Fine Papers | 569 Carter Court | Kimberly | Wisconsin 54136 | USA
T 920.830.4047 | **F** 920.830.4016 | **Direct** 1.800.779.0873 | michael@curiouspapers.com
www.curiouspapers.com

curious paper collection | **Popset** has a unique pearlescent finish that brings an unexpected dimension to graphic design: the colors on these optical-effect papers actually "flip" (and you will, too!) under shifting light. | **Keaykolour Metallics** have a surface sheen evocative of sheared metal, creating a glittering play of light in a range of alloy hues while delivering superb printability – and passing effortlessly through airport security. | **Canson Satin** first established the worldwide quality benchmark for translucent papers, then raised that mark still higher with an unrivaled selection of exciting and versatile designer colors. | **LightSpeck** is the original white-flecked paper, a superior-quality recycled sheet with tiny pale fibers...speckles...sprinkles... anyway, little bits of something lighter than the rest of the paper, including gold and silver flecks. | **Conqueror** is an internationally available, cotton-content letterhead range, competitively priced for the North American market and featuring a localized watermark for the best possible stationery design, plus special finishes such as ultra-smooth CX22. | **Sensation** is a revolutionary feltmarked sheet offering unparalleled high-quality reproduction of complex full-color imagery on a textured, uncoated paper.

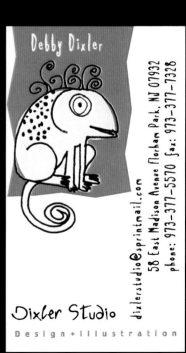

CLIENT: Arjo Wiggins Fine Papers

DESIGN FIRM: Viva Dolan Communications & Design

DESIGNER: Frank Viva

CLIENT: A & M Records

DESIGN FIRM: Sunja Park Design

ART DIRECTOR/DESIGNER: Sunja Park

SOFTWARE: Quark XPress

PAPER STOCK: Carolina C2S

PRINTING: 4-color process / direct digital

CLIENT: Sunja Park Design

DESIGN FIRM: Sunja Park Design

ART DIRECTOR/DESIGNER/ILLUSTRATOR:
Sunja Park

SOFTWARE: Quark XPress

PAPER STOCK: Quality leather embossed

PRINTING: 1 color / letterpress

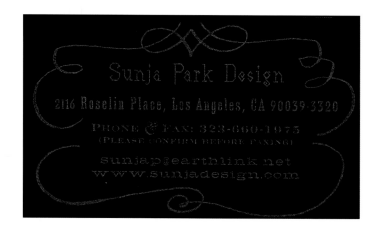

CLIENT: Christopher Palmer

DESIGNER: Christopher Palmer

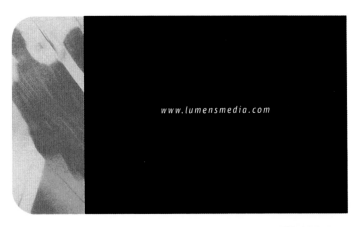

www.lumensmedia.com

ERIC BRADDY
account executive | *ericb@lumensmedia.com*

80 s. washington, #200 seattle, wa 98104
tel 206.628.8000 fax 206.467.1777
www.lumensmedia.com

LUMENSmedia

CLIENT: Lumens Media

DESIGN FIRM: Widmeyer Design

ART DIRECTOR: Ken Widmeyer

DESIGNER: Diana Chang

SOFTWARE: Macromedia Freehand

CLIENT: Eduard Čehovin Typographer

DESIGN FIRM: Kontrapunkt

ART DIRECTOR/DESIGNER: Eduard Čehovin

SOFTWARE: Adobe Illustrator

MATERIALS: Rubberband

PRINTING: Silkscreen

CENTRIS

connected for success

Centris, LLC
10900 NE 4th Street
Suite 2300
Bellevue, WA 98004
www.centris.net

SEATTLE BELLEVUE REDMOND

CENTRIS

BUSINESS CENTERS

MICHELLE MICEK AUDINO
owner

mmaudino@aol.com
Tel 425.635.7700

CLIENT: Centris Business Centers

DESIGN FIRM: Widmeyer Design

ART DIRECTOR: Ken Widmeyer

DESIGNER: Helen Kong

SOFTWARE: Macromedia Freehand

PAPER STOCK: Strathmore

PRINTING: Offset

SYLVIE MESNIER

HARMONIE KNITWEAR, INC

3131 WESTERN AVE, SUITE 327

SEATTLE, WA 98121

TEL: 206.216.0913 / 800.435.4518

FAX: 206.216.0914

URL: WOLFENET.COM/~HARMONIE

HARMONIE

CLIENT: Harmonie Knitwear

DESIGN FIRM: Widmeyer Design

ART DIRECTOR: Ken Widmeyer

DESIGNER: Barbara Dunshee

SOFTWARE: Macromedia Freehand

CLIENT: Greteman Group

DESIGN FIRM: Greteman Group

CREATIVE DIRECTOR: Sonia Greteman

ART DIRECTORS: Sonia Greteman /
James Strange

DESIGNER: James Strange

SOFTWARE: Macromedia Freehand

PAPER STOCK: Lightspeck Dune / 80 lb.

PRINTING: 2 colors spot offset / die-cut

CLIENT: Wild Man Productions

DESIGN FIRM: Greteman Group

CREATIVE DIRECTOR: Sonia Greteman

ART DIRECTORS: Sonia Greteman /
James Strange

DESIGNER: James Strange

SOFTWARE: Macromedia Freehand

PAPER STOCK: Classic Laid Camel Hair / 100 lb.

PRINTING: Spot color

CLIENT: Dynamo Art & Design

DESIGN FIRM: Dynamo Art & Design

ART DIRECTOR/DESIGNER: Nina Wishnok

SOFTWARE: Quark XPress

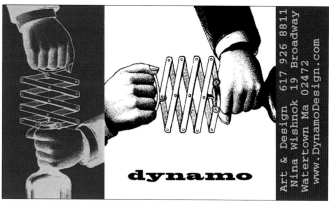

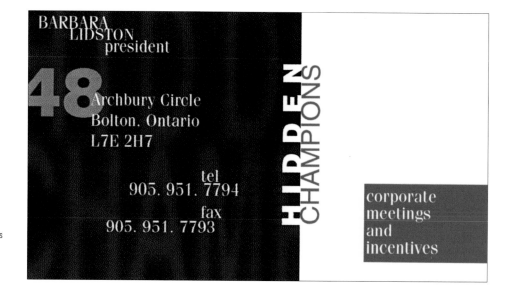

CLIENT: Hidden Champions

DESIGN FIRM: Terrapin Graphics

ART DIRECTOR/DESIGNER/ILLUSTRATOR: James Peters

SOFTWARE: Adobe Photoshop / Quark XPress

PRINTING: 4-color process

CLIENT: Nichols Graphic Design

DESIGN FIRM: Nichols Graphic Design

ART DIRECTOR/DESIGNER: Mary Ann Nichols

SOFTWARE: Quark XPress

PAPER STOCK: Deluxe white / medium weight

PRINTING: Black and PMS 185

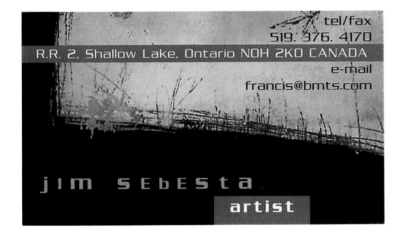

CLIENT: Jim Sebesta

DESIGN FIRM: Terrapin Graphics

ART DIRECTOR/DESIGNER: James Peters

ILLUSTRATOR: Jim Sebesta

SOFTWARE: Adobe Photoshop / Quark

PAPER STOCK: San Remo / matte

PRINTING: 4-color process

MARY ANN NICHOLS

GRAPHIC DESIGNER

80 EIGHTH AVENUE

SUITE 900

NEW YORK, NY 10011

212 727-9818

FAX: 212 727-9812

NGD80@AOL.COM

CLIENT: Open Think

DESIGN FIRM: Amoeba Corp.

ART DIRECTORS: Jason Darbyson /
Michael Kelar

DESIGNER: Jason Darbyson

SOFTWARE: Adobe Illustrator

PAPER STOCK: Beckett Expressions Super
Smooth Radiance 100 lb. cover

CLIENT: Cratos

DESIGN FIRM: Amoeba Corp.

ART DIRECTOR: Michael Kelar

DESIGNERS: Noel Nanton / Michael Kelar

SOFTWARE: Adobe Illustrator

PAPER STOCK: Cougar White 100 lb. cover

CLIENT: Le Petite Épicerie

DESIGN FIRM: Fabrice Praeger

ART DIRECTOR/DESIGNER: Fabrice Praeger

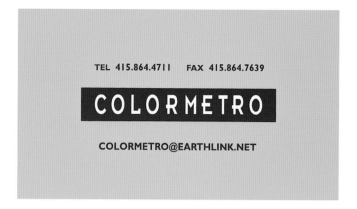

COLORMETRO@EARTHLINK.NET

DAVID HOLDEN

COLORMETRO

325 NINTH STREET SAN FRANCISCO CA 94103

CLIENT: Colormetro

DESIGN FIRM: Colormetro

ART DIRECTOR: David Holden

DESIGNER: Tania Rutherford

SOFTWARE: Adobe Illustrator

Dick

Dick

See Dick.

Dick Chin
Art Director

218 Ontario Street
Toronto, Ontario
M5A 2V5 Canada

t: (416) 203-1942
e: dickchin@globalserve.net
f: (416) 368-3947

CLIENT: Dick Chin Art Direction

DESIGN FIRM: Dick Chin Art Direction

ART DIRECTOR/DESIGNER: Dick Chin

CLIENT: Jerry King Musser

DESIGN FIRM: Musser

ART DIRECTOR/DESIGNER: Jerry King Musser

SOFTWARE: Adobe Photoshop /
Adobe Illustrator

PAPER STOCK: Epson Archival Matte

PRINTING: Epson Stylus Photo 2000P

jeanne f. goodman

1334 botetourt gardens
norfolk, virginia 23517
(757) 627 3113
www.bway.net/~ jgoodman

CLIENT: Jeanne F. Goodman

DESIGN FIRM: Jeanne F. Goodman

ART DIRECTOR/DESIGNER/ILLUSTRATOR:
Jeanne F. Goodman

CLIENT: António Sá + Ana Pedrosa

DESIGN FIRM: R2 Design

ART DIRECTORS/DESIGNERS: Lizá Defossez /
Artur Rebelo

SOFTWARE: Macromedia Freehand

PAPER STOCK: Brown kraft 260 grms

PRINTING: 2 over 1 offset / die-cut

Repórteres Freelance
Rua 33 | 1253 | 5º DF
4500 - 313 Espinho | Portugal
Tel/ fax +351. 227 346 191
Email: asapfoto@mail.telepac.pt

antónio sá + ana pedrosa

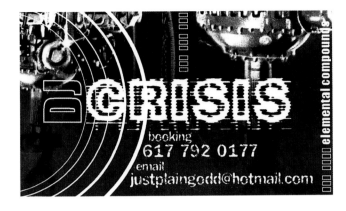

CLIENT: Elemental Compounds

DESIGN FIRM: Zenvironments

ART DIRECTOR/DESIGNER/ILLUSTRATOR:
Zachariah Johnsen

SOFTWARE: Adobe Photoshop /
Adobe Illustrator

PAPER STOCK: Epson Heavyweight Matte Paper

PRINTING: Epson Photo Stylus 1270

CLIENT: Carnase, Inc.

DESIGN FIRM: Carnase, Inc.

ART DIRECTOR/DESIGNER: Tom Carnase

Twenty One Dorset Road · *Scarsdale, N.Y. 10583*
(212) 777-1500
Fax: (212) 979-1927

Tom Carnase

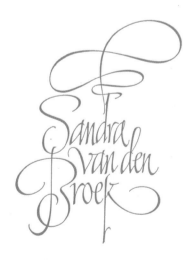

FINE ART & ANTIQUES
68 EAST 86TH STREET
NEW YORK, NEW YORK 10028
PHONE: 212 717 6711
FAX: 212 734 2465

CLIENT: Sandra Van den Broek

DESIGN FIRM: Carnase Inc.

ART DIRECTOR/DESIGNER: Tom Carnase

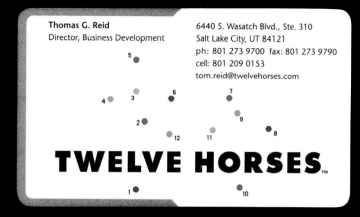

Thomas G. Reid
Director, Business Development

6440 S. Wasatch Blvd., Ste. 310
Salt Lake City, UT 84121
ph: 801 273 9700 fax: 801 273 9790
cell: 801 209 0153
tom.reid@twelvehorses.com

TWELVE HORSES™

CLIENT: Twelve Horses

DESIGN FIRM: Hornall Anderson Design
Works, Inc.

ART DIRECTOR: Jack Anderson

DESIGNERS: Jack Anderson / Lisa Cerveny /
Mary Chin Hutchinson /
Don Stayner

SOFTWARE: Macromedia Freehand /
Adobe Photoshop

PAPER STOCK: Mohawk Superfine Eggshell

CLIENT: Red Square Systems

DESIGN FIRM: Landesberg Design Associates

ART DIRECTOR: Rick Landesberg

DESIGNERS: Vicki Carlisle / Rick Landesberg /
Joe Petrina / Mike Savitski

SOFTWARE: Quark Xpress / Adobe Illustrator

PAPER STOCK: Strathmore Writing Wove
Recycled Bright White /
110 lb. cover

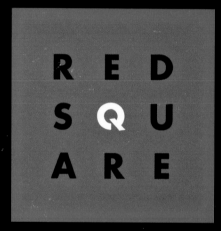

R E D
S Q U
A R E

RED SQUARE SYSTEMS
10 Bedford Square
Pittsburgh, Pennsylvania 15203

P 412 488 9170
F 412 488 9173
www.redsquaresystems.com

DESIGN + MULTIMEDIA

PERSONAL × SOCIAL
CHAOS × CALM

SACRED × PROFANE

inkahoots™
239 Boundary St | West End Q Australia 4101 | web www.inkahoots.com.au
ph +61 7 3255 0800 | fax +61 7 3255 0801 | email mail@inkahoots.com.au

CLIENT: Inkahoots

DESIGN FIRM: Inkahoots

DESIGNER: Jason Grant

CLIENT: Enki NY

DESIGN FIRM: Enki NY

ART DIRECTORS/DESIGNERS: Rosanne Kang /
Lana Le

SOFTWARE: Quark XPress

PAPER STOCK: Beckett Expression
Super Smooth

PRINTING: Offset litho

CLIENT: Beautyspy

DESIGN FIRM: Enki NY

ART DIRECTOR: Rosanne Kang

DESIGNERS: Sara Rotman / Michelle Handel

ILLUSTRATORS: Lana Le / Rosanne Kang

SOFTWARE: Quark XPress / Adobe Illustrator

Peter **Hall**

718 218 9760

718 218 7119 fax

peter**hall**@aol.com

:*(!/?;—},.

CLIENT: Peter Hall

DESIGN FIRM: Enki NY

ART DIRECTOR/DESIGNER: Lana Lee

SOFTWARE: Quark XPress

PAPER STOCK: Strathmore Ultimate
White Wove / 110 lb. cover

PRINTING: Offset litho

CLIENT: Digital Planet

DESIGN FIRM: Dotzero Design

ART DIRECTORS/DESIGNERS: Karen Wippich / John Wippich

SOFTWARE: Adobe Illustrator / Adobe Photoshop

CLIENT: Ecclissi

DESIGN FIRM: Enki NY

ART DIRECTORS/DESIGNERS: Rosanne Kang / Lana Le

PHOTOGRAPHER: Ron Reeves

SOFTWARE: Quark XPress

PAPER STOCK: Neenah Classic Crest Super Smooth

PRINTING: Offset litho

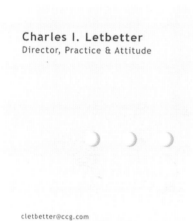

Charles I. Letbetter
Director, Practice & Attitude

cletbetter@ccg.com

CLIENT: Crossroads Consulting Group (CCG)

DESIGN FIRM: Wages Design

ART DIRECTOR: Bob Wages

DESIGNER: Rina Motokawa

SOFTWARE: Adobe Illustrator / Quark XPress

PRINTING: 4 colors / die-cut

CLIENT: CrunchTime Marketing

DESIGN FIRM: Wages Design

ART DIRECTOR: Bob Wages

DESIGNER/ILLUSTRATOR: Dominga Lee

SOFTWARE: Adobe Illustrator / Quark XPress

PRINTING: 3 colors

Dana Perkins 650-948-5132 tel 650-948-8620 fax
Principal dperkins@crunchtimemarketing.com

CrunchTimeMarketing

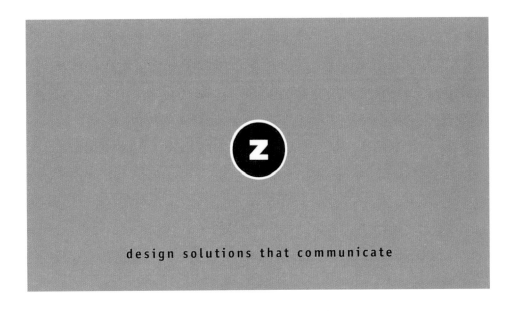

design solutions that communicate

LOUANN ZELLER
Vice President

ZGraphics, Ltd. 322 North River Street, East Dundee, Illinois 60118
847.836.6022 fax 847.836.6122 la@zgraphics.com www.zgraphics.com

CLIENT: ZGraphics, Ltd.

DESIGN FIRM: ZGraphics, Ltd.

ART DIRECVTOR: Joe Zeller

DESIGNER: Renee Clark

SOFTWARE: Quark XPress

PAPER STOCK: Neenah Classic Crest
Solar White

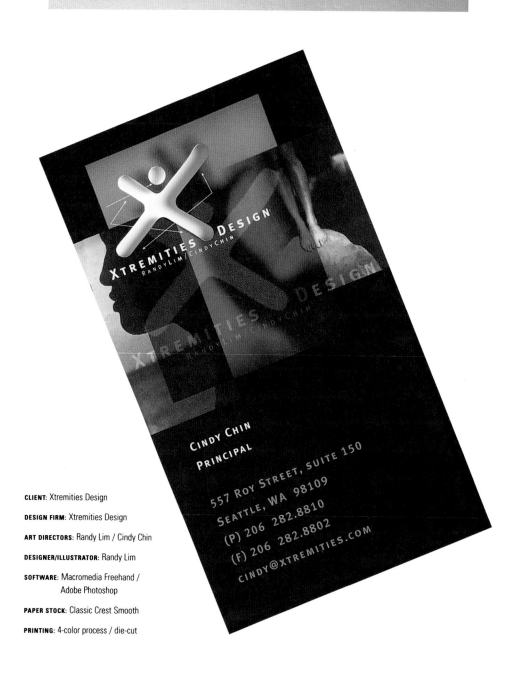

CEO

ROBERT "BOB" KAY

[604]891-4017
greywolfbc@hotmail.com www.greywolfentertainment.com
BOX 61531, BROOKSWOOD PO, LANGLEY, BC CANADA V3A 8C8

CLIENT: Greywolf Entertainment

DESIGN FIRM: Kelman Design

ART DIRECTOR: Keli Manson

SOFTWARE: Adobe Photoshop / Quark XPress

PAPER STOCK: Luna Gloss Cover

XTREMITIES DESIGN
RANDYLIM/CINDYCHIN

CINDY CHIN
PRINCIPAL
557 ROY STREET, SUITE 150
SEATTLE, WA 98109
(P) 206 282.8810
(F) 206 282.8802
CINDY@XTREMITIES.COM

CLIENT: Xtremities Design

DESIGN FIRM: Xtremities Design

ART DIRECTORS: Randy Lim / Cindy Chin

DESIGNER/ILLUSTRATOR: Randy Lim

SOFTWARE: Macromedia Freehand / Adobe Photoshop

PAPER STOCK: Classic Crest Smooth

PRINTING: 4-color process / die-cut

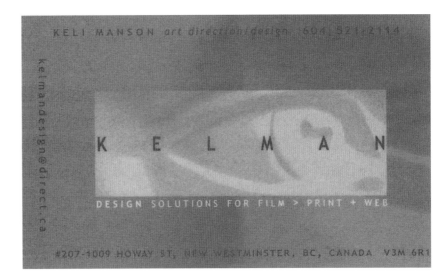

CLIENT: Kelman Design

DESIGN FIRM: Kelman Design

ART DIRECTOR: Keli Manson

SOFTWARE: Adobe Photoshop/Quark XPress

PAPER STOCK: Chartham Translucent

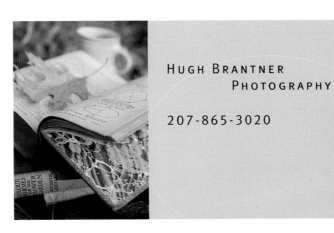

CLIENT: Hugh Brantner Photography

DESIGN FIRM: Brown Design & Co.

ART DIRECTOR/DESIGNER: Mary Brown

SOFTWARE: Adobe Photoshop / Quark

PAPER STOCK: Strobe Dull

PRINTING: 4 over 4

CLIENT: The Perfect Basket

DESIGN FIRM: Brown Design & Co.

ART DIRECTOR/DESIGNER: Mary Brown

SOFTWARE: Quark XPress

PAPER STOCK: Classic Crest

PRINTING: 2 over 2

Baskets for Any Occasion

Anniversary	Easter	Hostess Gift	Thanksgiving
Appreciation	Employee	Housewarming	Thinking of You
Baby Shower	Recognition	Mother's Day	Valentine's Day
Bereavement	Father's Day	New Job	Visiting VIPs
Birthday	Get Well	Nurse's day	Wedding
Bon Voyage	Golf Outing	Referrals	Wedding Shower
Christmas	Halloween	Retirement	
Congratulations	Hanukkah	Secretary's Day	

Juli P. Chicoine

President

144 HOWE STREET, LEWISTON, ME 04240

207-782-6300 800-750-6300 FAX:207-782-0420

The Perfect Basket

Custom Designed Gift Baskets
for Corporate & Personal Gift Giving

CLIENT: Anne Pundyk

DESIGN FIRM: Brown Design & Co.

Art Director/Designer: Mary Brown

ILLUSTRATOR: Anne Pundyk

SOFTWARE: Quark XPress

PAPER STOCK: Strobe Dull

PRINTING: 4 over 4

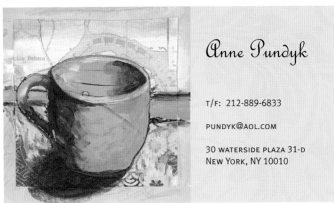

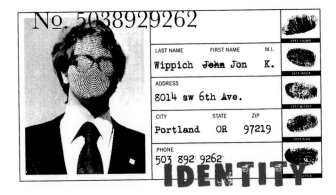

CLIENT: Dotzero Design

DESIGN FIRM: Dotzero Design

ART DIRECTORS/DESIGNERS: Karen Wippich /
Jon Wippich

SOFTWARE: Adobe Illustrator /
Adobe Photoshop

CLIENT: Mr. Swap

DESIGN FIRM: be.design

ART DIRECTOR: Will Burke

DESIGNERS: Eric Read / Yusuke Asaka / John Meeks

ILLUSTRATOR: John Meeks

SOFTWARE: Adobe Illustrator

PAPER STOCK: Card stock

PRINTING: 2 colors

Patrick Ford
PRESIDENT

T (415) 495 · 5700
F (415) 495 · 8465

pford@MrSwap.com

40 First Street · 5th Floor
San Francisco · CA · 94105

RICH
RICH@3ST2.COM

THIRST
2043 W. WABANSIA
CHICAGO IL
773-384-8888
773-384-8855
WWW.3ST.COM

Barbara Valicenti
Thirst
132 W. Station Street
Barrington, IL 60010

T> 847·842·0222
F> 847·842·0220
E> barb@3st2.com
www.3st.com

"Keeping business in the black"

dakota brown

www.3st.com
2043 w.wabansia av
chicago.il.60647
ph: 773.384.8888
fx: " " .8855
dakota@3st2.com

professional
designer

CLIENT: Detroit Steam Engines Art & Design

DESIGN FIRM: Detroit Steam Engines
Art & Design

ART DIRECTOR/ILLUSTRATOR: Jeannette Gutierrez

SOFTWARE: Macromedia Freehand

PAPER STOCK: French Construction / 80 lb. cover

PRINTING: 1 color

ART + DESIGN
JEANNETTE GUTIERREZ
ART DIRECTOR/DESIGNER

306 MULHOLLAND
ANN ARBOR, MI 48103
PHONE: 734-662-5787
EMAIL ADDRESS:
JGUTIERREZ@CYBERNET.COM

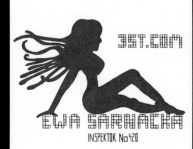

THIRST DESIGN MEAT MARKET

3ST.COM

EWA SARNACKA
INSPEKTOR No 420

2043 WABANSIA
CHICAGO IL 60647
T: 773.304.0000
F: 773.304.0055
E: EWA@3ST2.COM

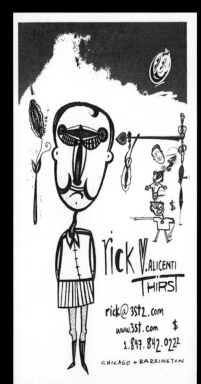

rick V. ALICENTI
THIRST

rick@3st2.com
www.3st.com $
1.847.842.0222

CHICAGO + BARRINGTON

CLIENT: Thirst

DESIGN FIRM: Thirst

ART DIRECTOR: Ms. Pickel

DESIGNERS/ILLUSTRATORS: Ewa Sarnacka /
Barbara Valicenti /
Rick Valicenti /
Rob Wittig /
Dakota Brown /
Rich Hanson /

SOFTWARE: Hand drawn, Adobe Photoshop

PAPER STOCK: Gilbert Neutech PS 120 lb. cover

CLIENT: LiquidSky

DESIGN FIRM: Design 360°

ART DIRECTOR/DESIGNER: D. Scott Evans

SOFTWARE: Adobe Photoshop /
Adobe Illustrator / Quark

PAPERSTOCK: Sappi Strobe Satin

PRINTING: 4-color process / varnish

Paul Graham Hayward
President/CEO
paul@liquidsky.com

LIQUIDSKY™

WorldViewVPN, Inc.
312.969.7285 direct
847.920.0332 fax

LiquidSky
global production resource
www.liquidsky.com

LiquidSky
global production resource
www.liquidsky.com

Paul Graham Hayward
President/CEO
paul@liquidsky.com

LIQUIDSKY™

LiquidSky
global production resource
www.liquidsky.com

Paul Graham Hayward
President/CEO
paul@liquidsky.com

LIQUIDSKY™

WorldViewVPN, Inc.
312.969.7285 direct
847.920.0332 fax

Martin Noel Copus
Director
martin@liquidsky.com

LIQUIDSKY™

LiquidSky
global production resource
www.liquidsky.com

WorldViewVPN, Inc.
+44(0)7881.908215 direct
+44(0)1491.412714 fax

LiquidSky
global production resource
www.liquidsky.com

Paul Graham Hayward
President/CEO
paul@liquidsky.com

LIQUIDSKY™

WorldViewVPN, Inc.
312.969.7285 direct
847.920.0332 fax

LiquidSky
global production resource
www.liquidsky.com

Paul Graham Hayward
President/CEO
paul@liquidsky.com

LIQUIDSKY™

WorldViewVPN, Inc.
312.969.7285 direct
847.920.0332 fax

LIQUIDSKY™

CLIENT: Design 360°

DESIGN FIRM: Design 360°

ART DIRECTOR/DESIGNER: D. Scott Evans

SOFTWARE: Adobe Illustrator

PAPER STOCK: Rising Museum Mounting Board

PRINTING: Front—letterpressed /
　　　　　 back—silkscreened

DESIGN-360° INCORPORATED
1144 WEST FULTON MARKET, CHICAGO, ILLINOIS 60607
312 491 8882 *voice*　312 491 8883 *fax*　DESIGN360.NET

D. SCOTT EVANS　SCOTT@DESIGN360.NET

CLIENT: Shawna Hill Graphic Designer

DESIGN FIRM: missHill Design

ART DIRECTOR/DESIGNER/ILLUSTRATOR:
　　　 Shawna Hill

SOFTWARE: Adobe Illustrator /
　　　　　 Adobe Photoshop /
　　　　　 Quark XPress

PAPER STOCK: 8 pt. back to back

PRINTING: 4-color process

Elizabeth Resnick

Assistant Professor of Graphic Design
Communication Design Department
Massachusetts College of Art
621 Huntington Avenue
Boston, MA 02115

t 617 232-1555 ext 360
f 617 566-4034

studio
Elizabeth Resnick Design
126 Payson Road
Chestnut Hill, MA 02467-3272

t 617 327-8965
f 617 327-7473
e ElizRes@aol.com

CLIENT: Elizabeth Resnick Design

DESIGN FIRM: Elizabeth Resnick Design

ARTDIRECTOR/DESIGNER/PHOTOGRAPHER:
Elizabeth Resnick

SOFTWARE: Adobe Photoshop / Quark XPress

PAPER STOCK: Potlatch Vintage Velvet

Damion Hickman
1801 Dove St, Suite 104
Newport Beach, CA 92660
Ph. 949.261.7857
Fax 949.261.5966
damion@damionhickman.com
www.damionhickman.com

CLIENT: Damion Hickman Design

DESIGN FIRM: Damion Hickman Design

ART DIRECTOR: Damion Hickmon

DESIGNER: Lane Durante

SOFTWARE: Adobe Illustrator

PRINTING: 4-color process / varnish 2 sides

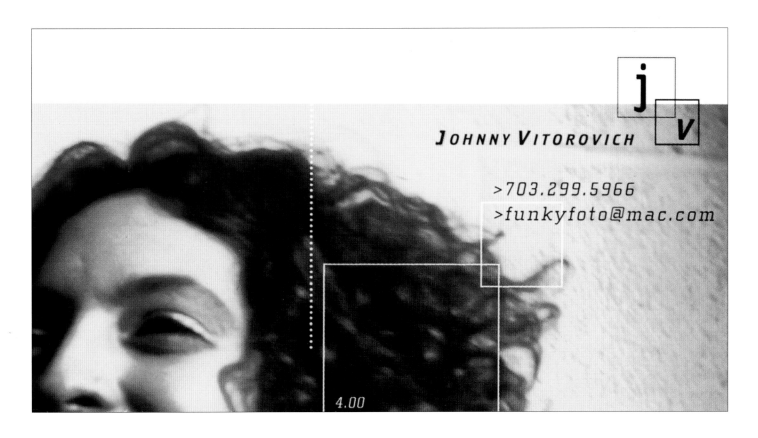

CLIENT: FunkyFoto

DESIGN FIRM: FunkyFoto

ART DIRECTOR/DESIGNER/ILLUSTRATOR:
Johnny Vitorovich

SOFTWARE: Adobe Photoshop / Quark

PAPER STOCK: Potlatch McCoy / matte

CLIENT: Ads & Art

DESIGN FIRM: Ads & Art

ART DIRECTOR: Jodi Eckes

DESIGNER: Jeremy Van Tassel

SOFTWARE: Adobe Illustrator / Quark XPress

PAPER STOCK: Beckett Expression / 100 lb. cover

PRINTING: Offset

Jodi Eckes
Graphic Designer

eckes.jodi@adsart.com

phone 507.282.9043
800.586.6774
fax 507.282.9537
web www.adsart.com

CLIENT: Acens

DESIGN FIRM: Summa

ART DIRECTOR: Wladimir Marnich

DESIGNER: Eduardo Cortada

SOFTWARE: Macromedia Freehand / Adobe Photoshop

PAPER STOCK: Fedrigoni Splendor Gel Extra White

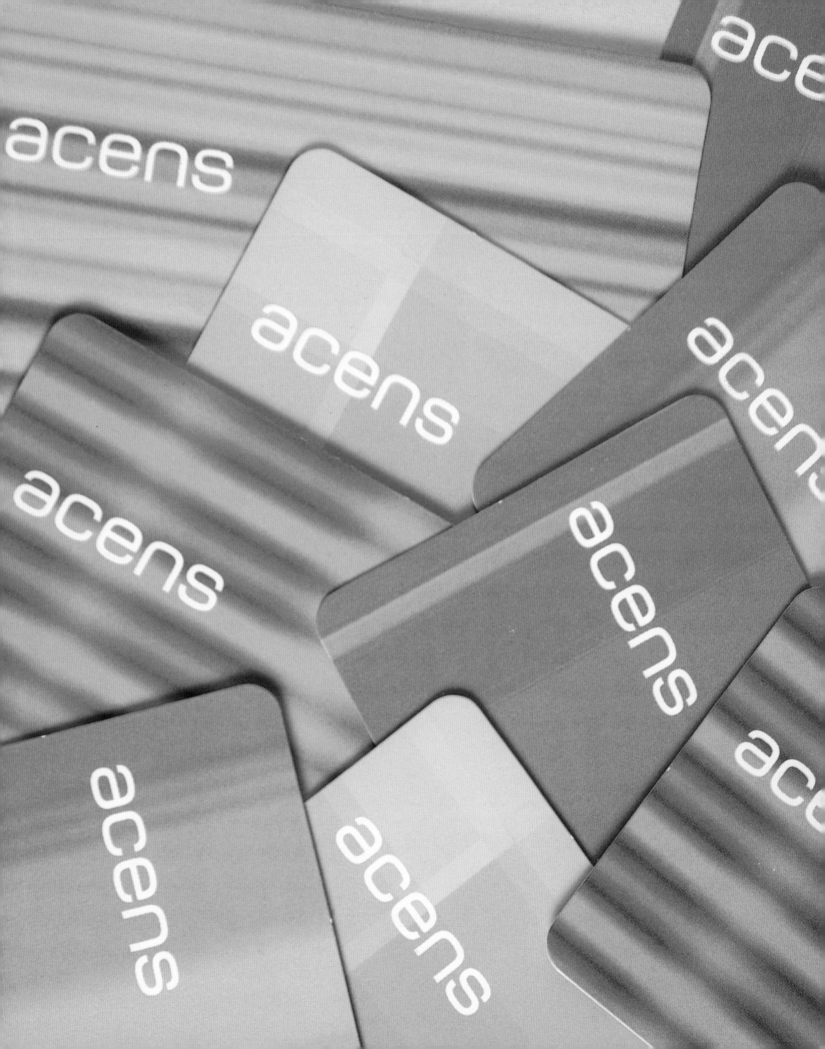

CLIENT: Voilà Disco

DESIGN FIRM: R & M Associati Grafici

DESIGNERS: Fontanella / Di Somma / Cesar

SOFTWARE: Adobe Illustrator

PRINTING: Offset

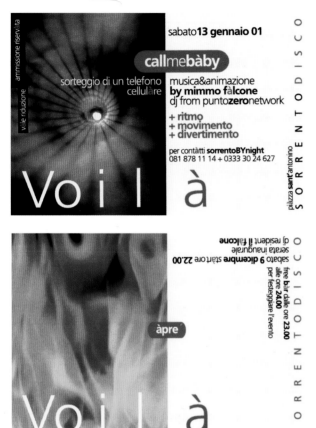

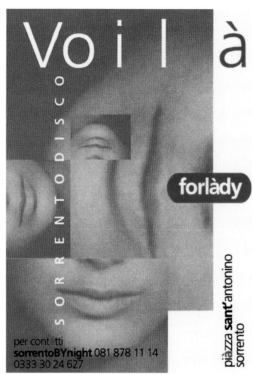

CLIENT: Emma Wilson Design Company

DESIGN FIRM: Emma Wilson Design Company

ART DIRECTOR/DESIGNER: Emma Wilson

SOFTWARE: Macromedia Freehand

PAPER STOCK: Neenah Environment

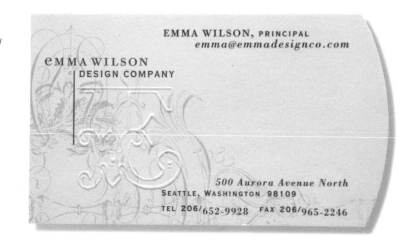

CLIENT: Atelier Tadeusz Piechura

Design Firm: Atelier Tadeusz Piechura

ART DIRECTOR/DESIGNER/ILLUSTRATOR:
Tadeusz Piechura

SOFTWARE: Corel

PRINTING: Offset

CLIENT: Matthew Borkoski Photography

DESIGN FIRM: Tim Kenney Design Partners

ART DIRECTOR: Tim Kenney

DESIGNER/ILLUSTRATOR: John Bowen

SOFTWARE: Adobe Photoshop

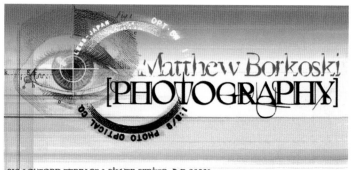

CLIENT: Transfer

DESIGN FIRM: Atelier Tadeusz Piechura

ART DIRECTOR/DESIGNER/ILLUSTRATOR:
Tadeusz Piechura

SOFTWARE: Corel

PRINTING: Offset

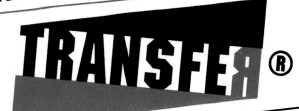

CLIENT: Museum Artystow
(The Artists' Museum)

DESIGN FIRM: Atelier Tadeusz Piechura

ART DIRECTOR/DESIGNER/ILLUSTRATOR:
Tadeusz Piechura

SOFTWARE: Corel

PRINTING: Laser printer

Muzeum Artystów ▲ The Artists' Museum

Tylna 14 ▲ 90·324 Łódź ▲ Poland ▲ tel./fax 042·741257

Tadeusz Piechura

Isabella Cechowicz

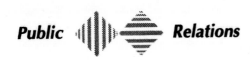

Public Relations

Tel. 0241/38429
Hubertusstr. 63, D-52064 Aachen

CLIENT: Isabella Cechowicz Public Relations

DESIGN FIRM: Atelier Tadeusz Piechura

ART DIRECTOR/DESIGNER/ILLUSTRATOR:
Tadeusz Piechura

SOFTWARE: Corel

PRINTING: Laser printer

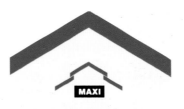

MAXI

Systemy dachowe MAXI

Mariusz Wieczorek
Sales Manager / Dyrektor Handlowy

CLIENT: Rautaruukki Polska

DESIGN FIRM: Atelier Tadeusz Piechura

ART DIRECTOR/DESIGNER/ILLUSTRATOR:
Tadeusz Piechura

SOFTWARE: Corel

PRINTING: Laser printer

RAUTARUUKKI POLSKA
STEEL STRUCTURE DIVISION Sp. z o.o.
ul. Jaktorowska 13, 96-300 Żyrardów
tel. 0 493 3461 0 90207564
fax 0 493 3758 0 90219751

CLIENT: Aha Pracownia Architektury

DESIGN FIRM: Atelier Tadeusz Piechura

ART DIRECTOR/DESIGNER/ILLUSTRATOR:
Tadeusz Piechura

SOFTWARE: Corel

PRINTING: Offset

AHA
PRACOWNIA ARCHITEKTURY
Jacek Bretsznajder ul. Wigury 28 m.17a, 90-319 Łódź, tel. 743000

CLIENT: Artfulgiving.com

DESIGN FIRM: Group Baronet

ART DIRECTOR: Meta Newhouse

DESIGNER: Bronson Ma

ARTFUL
GIVING.COM

Gina Cotroneo
6200 North Central Expressway Suite 220 Dallas Texas 75206 1.888.274.9225
P 214.775.6220 f 214.775.6221 c 214.274.8684 gina@artfulgiving.com

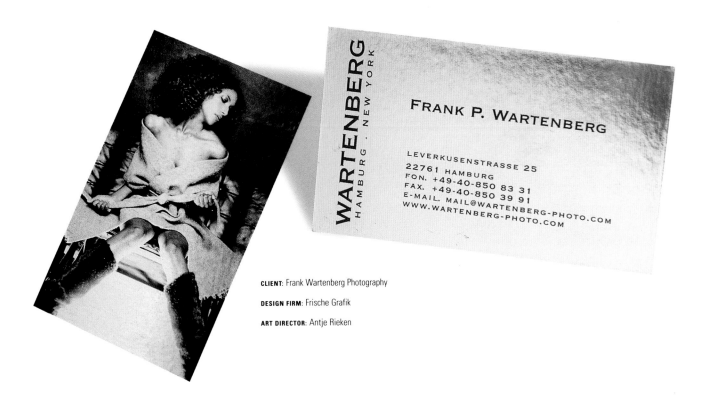

CLIENT: Frank Wartenberg Photography

DESIGN FIRM: Frische Grafik

ART DIRECTOR: Antje Rieken

CLIENT: Reich Paper

DESIGN FIRM: Drew Souza Design Studio

ART DIRECTOR: Drew Souza

SOFTWARE: Quark XPress

PAPER STOCK: Reich Paper Cartham
Translucents

PRINTING: 4-color process / white engraving

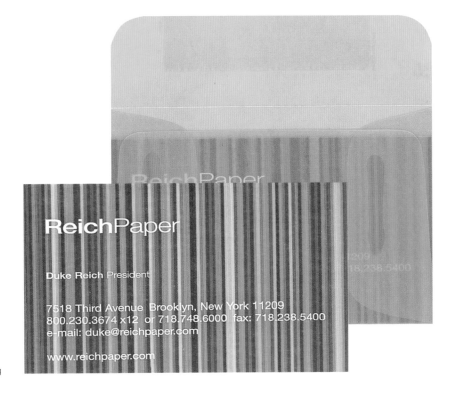

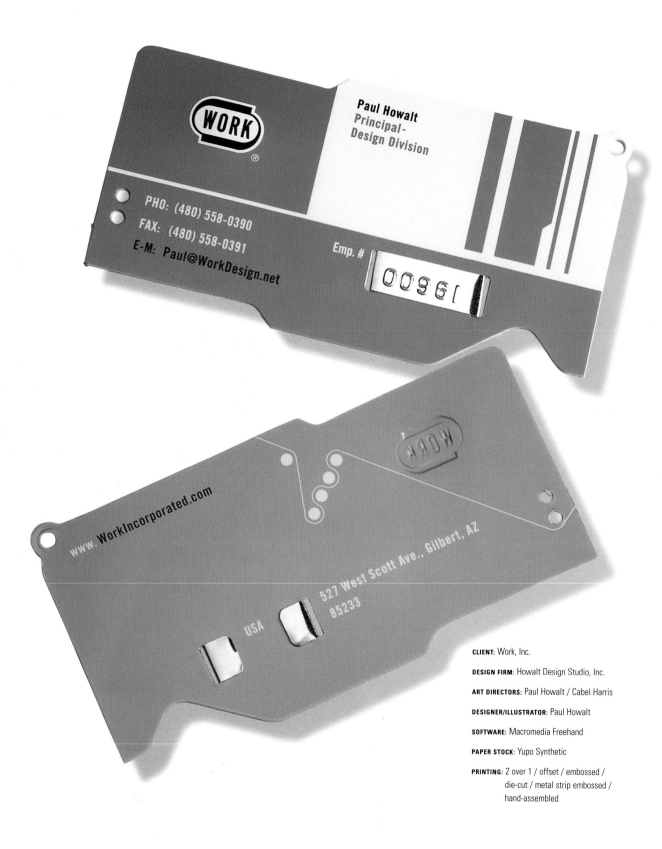

CLIENT: Work, Inc.

DESIGN FIRM: Howalt Design Studio, Inc.

ART DIRECTORS: Paul Howalt / Cabel Harris

DESIGNER/ILLUSTRATOR: Paul Howalt

SOFTWARE: Macromedia Freehand

PAPER STOCK: Yupo Synthetic

PRINTING: 2 over 1 / offset / embossed / die-cut / metal strip embossed / hand-assembled

WORK BRANDS

L.L.C.

(804) 358-9372

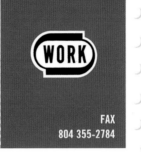
WORK

2019 Monument Ave.
Richmond, Virginia 23220 USA

FAX
804 355-2784

Patti Harris

CLIENT: Work Brands, L.L.C.

DESIGN FIRM: Howalt Design Studio, Inc.

ART DIRECTORS: Paul Howalt, Cabell Harris

DESIGNER/ILLUSTRATOR: Paul Howalt

SOFTWARE: Macromedia Freehand

PAPER STOCK: Springhill C1S

PRINTING: 2 colors offset with die-cut

MARK A. SOLOMON
BUSINESS SERVICES
* company accounts
* business plans
* financial reports/analysis

CONTACT INFO:

CLIENT: Mark A. Solomon

DESIGN FIRM: Planaria

ART DIRECTOR/DESIGNER/ILLUSTRATOR:
Nick Pimentel

SOFTWARE: Adobe Illustrator / Quark XPress

PAPER STOCK: Uncoated

PRINTING: 2 over 2 PMS colors

RATE CARD	GROSS SALES/INCOME		
	$100K- 200K	$35 per week	$12.50 hr
	$200K-350K	$50 per week	$15.00 hr
	$350-500K	$100 per week	$15.00 hr
	$500K-$1M	$150 per week	$17.50 hr *
	$1M-$2M	$250 per week	$17.50 hr *
	$2M+	negotiable *	
	* Includes 10 Hours Minimum, then Hourly Rate		

CLIENT: makeamall.com.

DESIGN FIRM: Howalt Design Studio, Inc.

ART DIRECTORS: Paul Howalt / Cabell Harris

DESIGNER/ILLUSTRATOR: Paul Howalt

SOFTWARE: Macromedia Freehand

PAPER STOCK: .30 Gauge plastic / MACtac StarLiner

PRINTING: 3 colors offset / die-cut

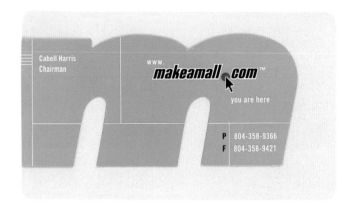

CLIENT: Eastern Edge Media Group, Inc.

DESIGN FIRM: Eastern Edge Media Group, Inc.

ART DIRECTOR/DESIGNER: M.J. Pressley-Jones

ILLUSTRATOR: Robert J. Jones

SOFTWARE: Quark XPress / Adobe Photoshop

PAPER STOCK: Ikono White / 100 lb. cover

REPUBLIKA HRVATSKA
MINISTARSTVO ZA OBRT, MALO I
SREDNJE PODUZETNIŠTVO
TAJNIŠTVO MINISTARSTVA

Vesna Berghaus
NAČELNICA ODJELA ZA OPĆE I KADROVSKE POSLOVE

T 01/4698 314, 4698 300
F 01/4698 313
E vberghaus@momsp.hr
Ksaver 200, 10000 Zagreb

REPUBLIC OF CROATIA
MINISTRY OF SMALL AND
MEDIUM ENTERPRISES
DIVISION FOR SMALL AND MEDIUM ENTERPRISES

Marina Lang Perica
HEAD OF SME DEVELOPMENT DEPT.

T ++ 385 1 4698 346, 4698 300
F ++ 385 1 4698 342
E mlperica@momsp.hr
Ksaver 200, 10000 Zagreb, Croatia

REPUBLIKA HRVATSKA
MINISTARSTVO ZA OBRT, MALO I
SREDNJE PODUZETNIŠTVO
UPRAVA ZA MEDUNARODNU SURADNJU

Boris Antunović
VIŠI SAVJETNIK U ODJELU ZA POTICANJE ULAGANJA

T 01/4698 367, 4698 300
F 01/4698 362
E boris.antunovic@momsp.hr
Ksaver 200, 10002 Zagreb

REPUBLIKA HRVATSKA
MINISTARSTVO ZA OBRT, MALO I
SREDNJE PODUZETNIŠTVO
UPRAVA ZA OBRT

Đurđica Vukovarac
NAČELNICA ODJELA ZA RAZVOJ OBRTA

T 01/4698 325, 4698 300
F 01/4698 322
E djvukovarac@momsp.hr
Ksaver 200, 10000 Zagreb

REPUBLIKA HRVATSKA
MINISTARSTVO ZA OBRT, MALO I
SREDNJE PODUZETNIŠTVO
UPRAVA ZA UPRAVNE I NORMATIVNE POSLOVE

Dragutin Katalenić
POMOĆNIK MINISTRA

T 01/4698 370, 4698 300
F 01/4698 372
E pravni.poslovi@momsp.hr
Ksaver 200, 10002 Zagreb

REPUBLIKA HRVATSKA
MINISTARSTVO ZA OBRT, MALO I
SREDNJE PODUZETNIŠTVO

Ivan Knok
ZAMJENIK MINISTRA

T 01/4698 303, 4698 300
F 01/4698 308
E zamjenik@momsp.hr
Ksaver 200, 10002 Zagreb

CLIENT: Ministry of Small and
Medium Enterprises

DESIGN FIRM: Likovni Studio D.O.O.

ART DIRECTOR: Danko Jaksic

DESIGNER: Tomislav Mrcic

SOFTWARE: Macromedia Freehand

PAPER STOCK: Kunstdruck 225 g/m2

PRINTING: Offset

REPUBLIKA HRVATSKA
MINISTARSTVO ZA OBRT, MALO I
SREDNJE PODUZETNIŠTVO
UPRAVA ZA ZADRUGE

Dubravka Bišćan
NAČELNICA ODJELA ZA RAZVOJ ZADRUGA

T 01/4698 335, 4698 300
F 01/4698 332
E dbiscan@momsp.hr
Ksaver 200, 10002 Zagreb

CLIENT: Mim Scalin

DESIGN FIRM: ALR Design

ART DIRECTOR: Noah Scalin

SOFTWARE: Adobe Photoshop / Quark

KILT&BAGEL
Productions, Inc.

Mahlon Stewart
executive producer

50 East 10th Street Suite 2E
New York. NY 10003-6226
917.533.4166
Fax 212.253.1734
mahlon@kiltandbagel.com

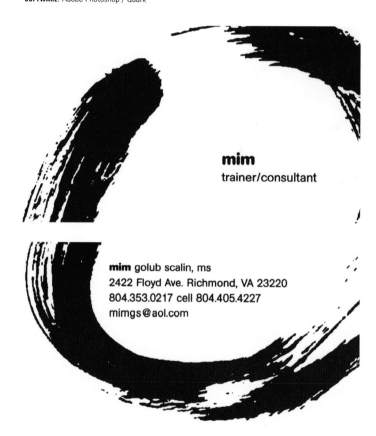

mim
trainer/consultant

mim golub scalin, ms
2422 Floyd Ave. Richmond, VA 23220
804.353.0217 cell 804.405.4227
mimgs@aol.com

CLIENT: Kilt & Bagel Productions Inc.

DESIGN FIRM: ALR Design

ART DIRECTOR: Noah Scalin

SOFTWARE: Adobe Photoshop /
Adobe Illustrator / Quark

PAPER STOCK: Crane Continuum Kenaf / soy ink

PRINTING: Handset lead type on a
handcranked letterpress

My Card

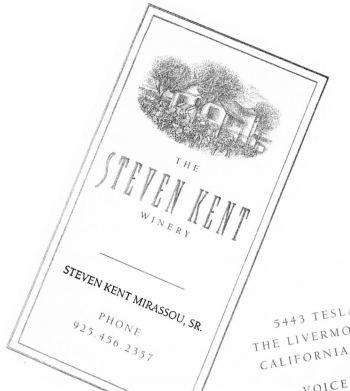

THE
STEVEN KENT
WINERY

STEVEN KENT MIRASSOU, SR.

PHONE
925.456.2357

CLIENT: The Steven Kent Winery

DESIGN FIRM: Tharp Did It

DESIGNER: Rick Tharp

ILLUSTRATOR: Michael Bull

SOFTWARE: Adobe Illustrator

PAPER STOCK: Fox River Starwhite

5443 TESLA ROAD
THE LIVERMORE VALLEY
CALIFORNIA 94550 USA

VOICE MAIL
800.999.2885 X2357

FAX
925.456.2376

E-MAIL
STEVEN@STEVENKENT.COM

WEBSITE
WWW.STEVENKENT.COM

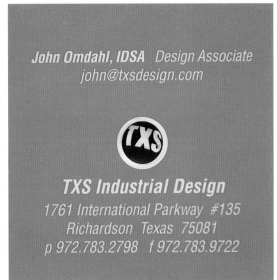

CLIENT: TXS Industrial Design, Inc.

DESIGN FIRM: TXS Industrial Design, Inc.

ART DIRECTOR: Tim Terleski

DESIGNERS: John Omadahl / Staci Mininger

SOFTWARE: Macromedia Freehand

PAPER STOCK: Phoenix Motion Cover /
 Xenan 93 lb.

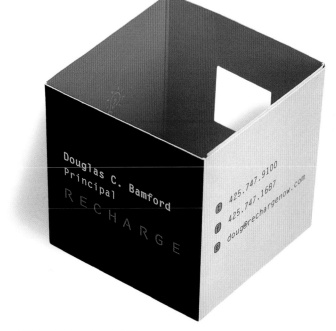

CLIENT: Recharge

DESIGN FIRM: Hornall Anderson Design
 Works, Inc.

ART DIRECTOR: Jack Anderson

DESIGNERS: Jack Anderson / Katha Dalton /
 Henry Yiu / Darlin Gray /
 Tiffany Scheiblauer /
 Brad Sherman

ILLUSTRATORS: Brad Sherman / Heidi Favour /
 Alan Florsheim

SOFTWARE: Macromedia Freehand

PAPER STOCK: Benefit

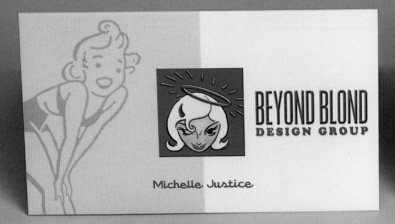

BEYOND BLOND
DESIGN GROUP

Michelle Justice

www.beyondblond.com
310·450·8294

Adobe
Certified Expert

We Prefer Great Design

The full-service
design firm catering to
the entertainment industry.
We've got you covered from
concept to finished product.
Call us today.

Adobe
Certified Expert

★ Art Direction
★ Graphic Design
★ Digital Imaging
★ Print Production
★ Print Brokerage
★ Web Sites
★ Multimedia

See our work at www.beyondblond.com

2602 22nd Street
Santa Monica
California
90405

MICHELLE JUSTICE
THE BLOND

310 ★ 450 ★ 8294

310.450.4963 FAX
310.259.8294 Cellular
Michelle@BeyondBlond.com

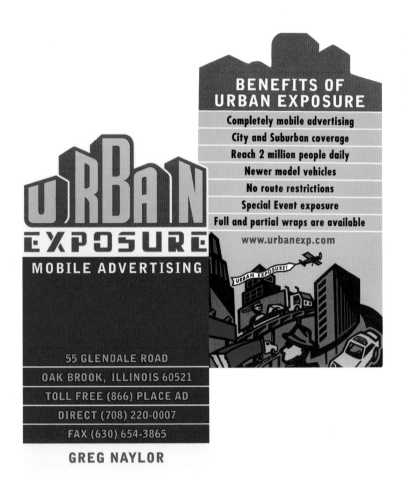

CLIENT: Urban Exposure

DESIGN FIRM: Sayles Graphic Design

ART DIRECTOR/DESIGNER/ILLUSTRATOR:
John Sayles

SOFTWARE: Adobe Illustrator

PAPER STOCK: Mohawk Navajo / 130 lb. cover

CLIENT: Kelling Management Group

DESIGN FIRM: Sayles Graphic Design

ART DIRECTOR/DESIGNER/ILLUSTRATOR:
John Sayles

SOFTWARE: Adobe Illustrator

PAPER STOCK: Mohawk Navajo / 80 lb. cover

CLIENT: Beyond Blond Design Group

DESIGN FIRM: Beyond Blond Design Group

ART DIRECTOR/DESIGNER/ILLUSTRATOR:
Michelle Justice

SOFTWARE: Adobe Photoshop /
Adobe Illustrator / Quark XPress

PRINTING: 4 colors / offset / 2 sides

CLIENT: Glazed Expressions

DESIGN FIRM: Sayles Graphic Design

ART DIRECTOR/DESIGNER/ILLUSTRATOR:
John Sayles

SOFTWARE: Adobe Illustrator

PAPER STOCK: Cougar Smooth White /
100 lb. cover

CLIENT: 3 Citron Caterers

DESIGN FIRM: Toolbox

ART DIRECTOR: Brian Liv

DESIGNERS: Brian Liv / Greg Stadnyk /
J. Robbins

SOFTWARE: Adobe Illustrator /
Adobe Photoshop /
Quark XPress

PAPER STOCK: Coated

PRINTING: 3 over 3

John Wolfe

140 High Street
Newburyport, MA 01950
Ph~ 978.462.1088
Fax~ 978.462.5265

CLIENT: BluWater Cafe

DESIGN FIRM: On The Edge Design

ART DIRECTOR/ILLUSTRATOR: Jeff Gasper

DESIGNER: Tracey Lamberson

SOFTWARE: Adobe Illustrator

PRINTING: 4 over 1

CLIENT: Jillian's

DESIGN FIRM: On The Edge Design

ART DIRECTOR: Jeff Gasper

DESIGNER: Gina Mims

ILLUSTRATOR: Moc

SOFTWARE: Adobe Photoshop / Quark XPress

PRINTING: 4 colors

JILLIAN'S

Michael Abraham
MANAGER

101 Fourth Street #170
San Francisco, CA 94103
Ph: 415-369-6100
Fax: 415-369-6103

CLIENT: Cabana Restaurant

DESIGN FIRM: On The Edge Design

ART DIRECTOR: Jeff Gasper

DESIGNER: Tracey Lamberson

SOFTWARE: Adobe Photoshop

PRINTING: 4 over 1

CLIENT: On The Edge Design

DESIGN FIRM: On The Edge Design

ART DIRECTOR: Jeff Gasper

DESIGNER: Gina Mims

SOFTWARE: Adobe Photoshop

PAPER STOCK: Luna Gloss cover

PRINTING: 4 colors

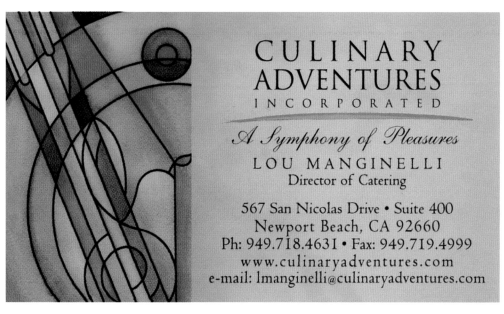

CLIENT: Culinary Adventures

DESIGN FIRM: On The Edge Design

ART DIRECTOR: Jeff Gasper

DESIGNERS: Gina Mims / Tracey Lamberson

ILLUSTRATOR: Gina Mims

SOFTWARE: Adobe Photoshop / Quark XPress

PRINTING: 4 over 4

SOFTWARE: Macromedia Freehand

PAPER STOCK: Bilderdruck matt

KOMMUNIKATIONSDESIGN

h a m m e r s t r . 1 5 6
4 5 2 5 7 e s s e n [r u h r]
w w w . m a n x d e s i g n . d e

CAROLA HANNUSCH
[M.A.]

Redaktion & PR

f o n 0 2 0 1 · 8 4 8 3 0 0
f a x 0 2 0 1 · 8 4 8 3 0 2 0
h a n n u s c h @ m a n x d e s i g n . d e

PETER HOWE
[Dipl. Kommunikationsdesigner]

Geschäftsführer

f o n 0 2 0 1 · 8 4 8 3 0 0
f a x 0 2 0 1 · 8 4 8 3 0 2 0
h o w e @ m a n x d e s i g n . d e

HELTZER incorporated

joseph litzenberger
vice president design

4853 NORTH RAVENSWOOD AVENUE
CHICAGO ILLINOIS 60640 4409
TEL 312 561 5612 FAX 312 561 5564

CLIENT: Heltzer, Inc.

DESIGN FIRM: Liska + Associates, Inc.

ART DIRECTOR: Steve Liska

DESIGNER: Susan Carlson

SOFTWARE: Quark XPress / Adobe Illustrator

PAPER STOCK: Strathmore Writing

CLIENT: Oman Photography.

DESIGN FIRM: Liska + Associates, Inc.

ART DIRECTOR: Steve Liska

DESIGNER: Erin Hasley

SOFTWARE: Quark XPress / Adobe Illustrator

PAPER STOCK: Gilcrest Gilclear

CLIENT: Northern Possessions

DESIGN FIRM: Liska + Associates, Inc.

ART DIRECTOR: Steve Liska

DESIGNER: Christina Nimry

SOFTWARE: Quark XPress / Adobe Illustrator

PAPER STOCK: Fox River Starwhite
 Performa Tiara Vellum

CLIENT: John Myers Photography

DESIGN FIRM: Dunn and Rice Design, Inc.

ART DIRECTOR: John Dunn

DESIGNERS: Michelle Danzer / John Dunn

SOFTWARE: Quark XPress / Adobe Illustrator

PAPER STOCK: Benefit Expressions

29 Richmond Street

Rochester, New York 14607

phone: 716-325-4547

cell phone: 716-747-2044

fax: 716-325-6403

john@johnmyersphoto.com

John Myers
President

JOHN MYERS PHOTOGRAPHY

CLIENT: By the Light of the Moon

DESIGN FIRM: Xtremities Design

ART DIRECTOR: Heather Lavin

DESIGNER: Randy Lim

SOFTWARE: Macromedia Freehand

PAPER STOCK: Various

PRINTING: Laser printing on various papers

by the Light of the Moon
Imaginative designs in home accessories

2459 24TH AVE E
SEATTLE, WA 98112
(P) 206 324-3793
EMAIL: HLAVIN@SPRYNET.COM

HEATHER LAVIN
OWNER

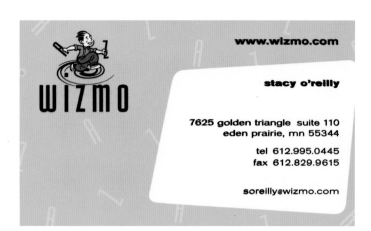

CLIENT: Wizmo

DESIGN FIRM: Studiomoon

ART DIRECTOR/DESIGNER/ILLUSTRATOR:
Tracy Moon

SOFTWARE: Adobe Photoshop /
Adobe Illustrator / Quark XPress

PAPER STOCK: Starwhite Vicksburg / 110 lb.

CLIENT: Tribe Pictures

DESIGN FIRM: Studiomoon

ART DIRECTOR: Tracy Moon

DESIGNERS: Tracy Moon / Kimberly Cross

SOFTWARE: Adobe Photoshop / Quark XPress

PAPER STOCK: Curtis Brightwater
Artesian White

tevin Adelman

TRiBE

Tribe pictures

174 Hudson
New York, NY 10013
tel 212/625/6565
Fax 212/343/0904
tevin@tribepictures.com
www.tribepictures.com

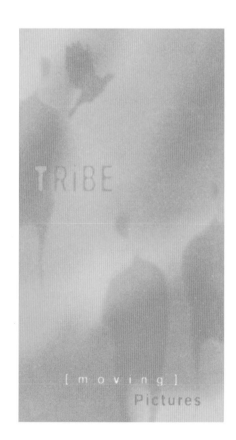

NEW LEAF
PAPER

MARY A. WEST
Director of Operations

TEL 415.291.9210
1.888.989.5323
215 Leidesdorff St. 4th floor
San Francisco, CA 94111

FAX 415.291.9353
mary@newleafpaper.com
www.newleafpaper.com

THIS CARD WAS MADE WITH
80 PERCENT POST-CONSUMER WASTE.

JUST THINK.
IN A PREVIOUS LIFE, IT WAS PROBABLY
SOMEBODY ELSE'S BUSINESS CARD.

CLIENT: New Leaf Paper

DESIGN FIRM: Elixir Design

ART DIRECTOR: Jennifer Jerde

DESIGNER: Nathan Durrant

SOFTWARE: Quark XPress

PAPER STOCK: New Leaf Reincarnation

CLIENT: Pomegranit

DESIGN FIRM: Elixir Design

ART DIRECTOR: Jennifer Jerde

DESIGNER: Michael Braley

SOFTWARE: Adobe Illustrator

PAPER STOCK: Chipboard / fat latex / tape

poməgranit | AN EDITORIAL COMPANY | *Kim Bica*

*p.*415.291.5800 *f.*415.291.5801 *e.*edit@pom.com
50 green street **san francisco** california 94111

poməgranit | AN EDITORIAL COMPANY |

*p.*415.291.5800 *f.*415.291.5801 *e.*edit@pom.com
50 green street **san francisco** california 94111

CLIENT: Weaver & Co.

DESIGN FIRM: Elixir Design

ART DIRECTOR: Jennifer Jerde

DESIGNER: Jennifer Breeze

SOFTWARE: Adobe Illustrator

PAPER STOCK: Chipboard

CLIENT: Snowden & Co.

DESIGN FIRM: Elixir Design

ART DIRECTOR: Jennifer Jerde

DESIGNER: Jennifer Breeze

SOFTWARE: Adobe Illustrator

PAPER STOCK: Champion Benefit

CLIENT: Tony Stromberg

DESIGN FIRM: Elixir Design

ART DIRECTOR/DESIGNER: Jennifer Jerde

SOFTWARE: Adobe Illustrator

PAPER STOCK: Chipboard

PRINTING: Silkscreened

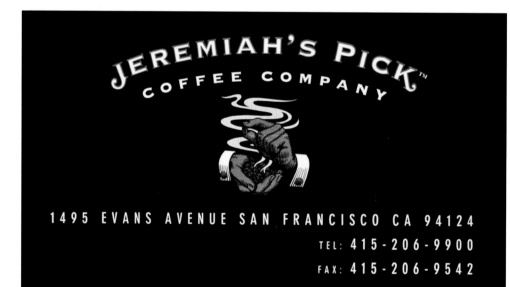

CLIENT: Jeremiah's Pick

DESIGN FIRM: Elixir Design

ART DIRECTOR/DESIGNER: Jennifer Jerde

ILLUSTRATOR: Tom Hennessy

SOFTWARE: Adobe Illustrator

Melanie Diehn Beratung - Verkauf

Neuer Wall 71 | 20354 Hamburg
Telefon 040.37 49 70 - 0 (21) | Telefax 040.37 63 53 - 53

e-mail: diehn@dahlercompany.de

CLIENT: Dahler & Company

DESIGN FIRM: Formgefühl

ART DIRECTOR/DESIGNER: Marius Fahrner

SOFTWARE: Macromedia Freehand

PAPER STOCK: IGEPA–Agrippina Offset

PRINTING: 2 colors / offset

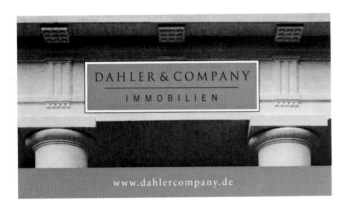

INFORMATIONART

INFORMATIONART

INFORMATIONART

STRAUSFELD@INFORMATIONART.COM

INFORMATIONART

CLIENT: Informationart

DESIGN FIRM: Elixir Design

ART DIRECTOR: Jennifer Jerde

DESIGNERS/ILLUSTRATORS: Holly Holmquist /
Nathan Durrant

SOFTWARE: Adobe Illustrator

PAPER STOCK: Champion Kromekote

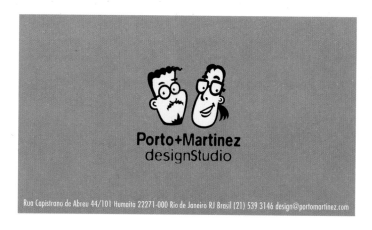

CLIENT: Porto + Martinez Design Studio

DESIGN FIRM: Porto + Martinez Design Studio

ART DIRECTORS/DESIGNERS/ILLUSTRATORS:
Marcelo Martinez / Bruno Porto

SOFTWARE: Quark XPress / Corel Draw

PAPER STOCK: 180 g/m2 non-coated
white paper

PRINTING: 2 over 1 / offset

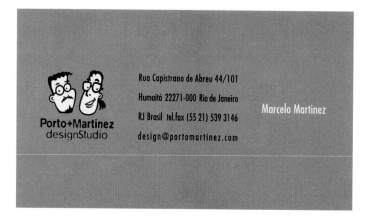

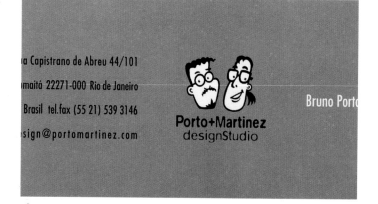

MARK F. STEIN D.D.S FAMILY & COSMETIC DENTISTRY 16055 VENTURA BLVD. SUITE 925 ENCINO CA 91436 PHONE 818 788 5556 FAX 818 788 6907 E MAIL toothbizz@aol.com

CLIENT: Mark F. Stein (dentist)

DESIGN FIRM: Cross Colours Inc.

ART DIRECTORS: J. Pastoll / J. Rech

DESIGNER: J. Rech

ILLUSTRATOR: Chiara Rech

SOFTWARE: Macromedia Freehand /
Adobe Photoshop

PRINTING: 4-color process

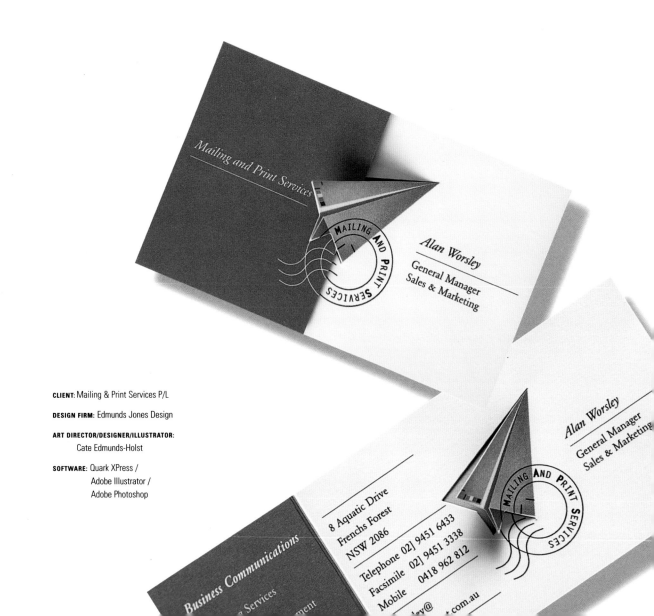

CLIENT: Mailing & Print Services P/L

DESIGN FIRM: Edmunds Jones Design

ART DIRECTOR/DESIGNER/ILLUSTRATOR:
Cate Edmunds-Holst

SOFTWARE: Quark XPress /
Adobe Illustrator /
Adobe Photoshop

CLIENT: Just Sprinklers

DESIGN FIRM: Rome & Gold Ltd.

ART DIRECTOR: Lorenzo Romero

DESIGNER/ILLUSTRATOR: Robert E. Goldie

SOFTWARE: Adobe Illustrator

Just
sprinklers

Micah Schultz - Manager

8330 Washington Pl NE
Albuquerque, NM 87113

5 0 5 · 7 9 7· 3 3 8 4

"Trust in Just!"

MS-6 Sprinkler
License#56457

Certified Back Flow
Prevention#458

Certified Landscape
Irrigation Auditor

05'　　　　　00'　　　　　55'

LIGHTHOUSE DIGITAL

26 Lombard Street East, Dublin 2, Ireland
T : +353 1 672 9070　**F** : +353 1 672 9071　**E** : mark@lhd.ie

Mark Ryan director

CLIENT: Lighthouse Digital

DESIGN FIRM: Dynamo

DESIGNER: Brian Nolan

SOFTWARE: Adobe Photoshop / Quark XPress

CLIENT: Dynamo

DESIGN FIRM: Dynamo

DESIGNER: Brian Nolan

SOFTWARE: Quark XPress

dynamo

dynamo

dynamo

dynamo

dynamo

dynamo

dynamo

dynamo

CLIENT: Winking Owl Studios

DESIGN FIRM: Winking Owl Studios

ART DIRECTOR/DESIGNER/ILLUSTRATOR:
Jo Williams

PAPER STOCK: Neenah Classic Linen /
Greystone 80 lb.

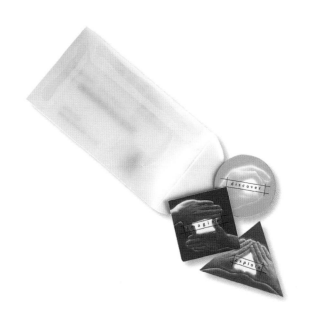

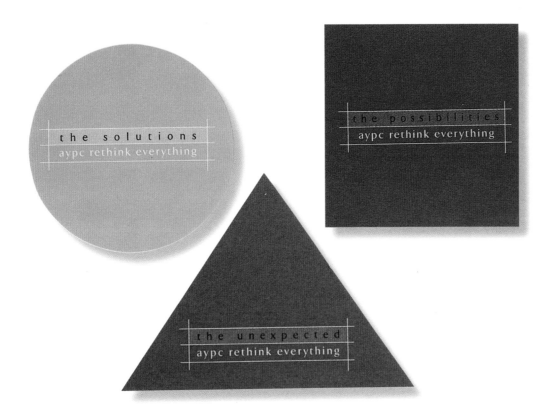

CLIENT: Aumiller Youngquist, P.C.

DESIGN FIRM: JOED Design Inc.

ART DIRECTOR: Edward Rebek

DESIGNER: Tim Pressley

SOFTWARE: Macromedia Freehand

PAPER STOCK: Strathmore Writing / Vellum

PRINTING: Vellum envelope 3 colors /
inserts 2 over 2

O'LEARY WALKER WINES

CLIENT: O'Leary Walker Wines

DESIGN FIRM: CPd — Chris Perks Design

ART DIRECTOR: Chris Perks

DESIGNER: Alan Morrison

SOFTWARE: Adobe Illustrator

PAPER STOCK: Threads Natural 280 gsm

PRINTING: 3 colors plus black foil

NICK WALKER
Winemaker

O'Leary Walker Wines
2 Hobbs Street
Tanunda 5352
South Australia
Phone 08) 8563 2354
Fax 08) 8333 0072
Mobile 0407 957 855
E-mail nwalker@
asiaonline.net.au

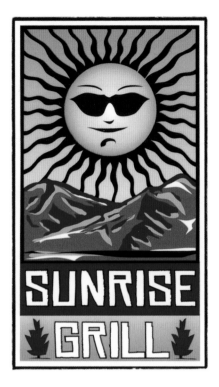

SUNRISE GRILL

RENEE BRANTON

Front Manager

1675 HWY. 105
BOONE, NC 28607
828.262.5400

Rise to a new altitude!

CLIENT: Sunrise Grill

DESIGN FIRM: High Noon Studios

ART DIRECTOR: Kim Ferguson

DESIGNER/ILLUSTRATOR: Will Blaine

SOFTWARE: Adobe Illustrator

BECCA SHEPHERD

BSM Peak Coordinator

BROOKWOOD COMMUNITY CHURCH

3161 S. HWY. 14
GREENVILLE, SC 29615

phone
864.297.1736
fax
864.458.7007

CLIENT: Brook Wood Community Church

DESIGN FIRM: High Noon Studios

ART DIRECTOR: Tagg Wolverton

DESIGNER/ILLUSTRATOR: Will Blaine

SOFTWARE: Adobe Illustrator

PALAZZOLO DESIGN STUDIO

6410 KNAPP ADA MICHIGAN 49301
P 616 676 9979 F 616 676 1579
●-mail palazzol@iserv.net

CLIENT: Palazzolo Design Studio

DESIGN FIRM: Palazzolo Design Studio

ART DIRECTOR: Greg Palazzolo

DESIGNER: Troy Gough

SOFTWARE: Adobe Illustrator

PAPER STOCK: Hammermill Via

PALAZZOLO DESIGN STUDIO

6410 KNAPP ADA MICHIGAN 49301
P 616 676 9979 F 616 676 1579
●-mail palazzol@iserv.net

PALAZZOLO DESIGN STUDIO

6410 KNAPP ADA MICHIGAN 49301
P 616 676 9979 F 616 676 1579
●-mail palazzol@iserv.net

Andrew Smith - Chef

Bostwick Lake Inn ~ 8521 Belding Road ~ Rockford, Michigan ~ 616-874-7290

8521 Belding Road ~ Cannon Township

THE BOSTWICK LAKE INN

RESTAURANT ~ SPIRITS ~ SPECIALTY GOODS

Rockford, Michigan 49341 ~ 616-874-7290

Bostwick Lake Inn ~ 8521 Belding Road ~ Rockford, Michigan ~ 616-87...

Packaged Liquor Store
The Bostwick Lake Inn
BEER
LIQUOR
WINE

CLIENT: Bostwick Lake Inn

DESIGN FIRM: Palazzolo Design Studio

ART DIRECTOR: Greg Palazzolo

DESIGNER: Troy Gough

SOFTWARE: Adobe Illustrator / Adobe Photoshop

PAPER STOCK: Hammermill Via

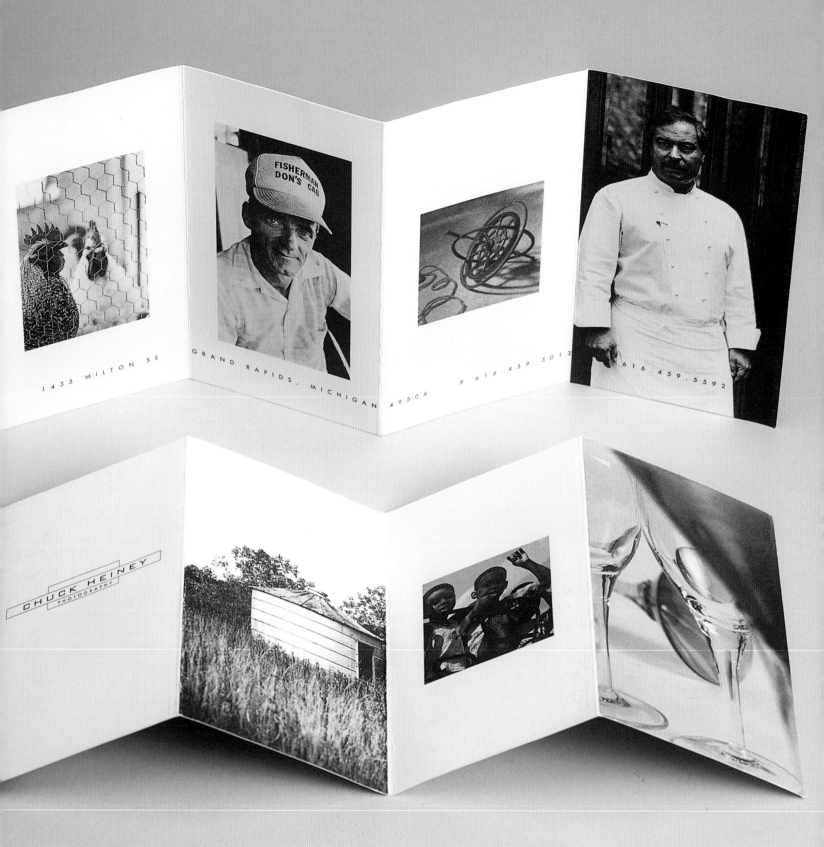

1435 MILTON SE GRAND RAPIDS, MICHIGAN 49506 P 616.459.3013 616.459.5592

CHUCK HEINEY
PHOTOGRAPHY

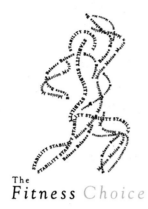

The
Fitness Choice
Personal Training Services

Deborah G. Robinson

P.O. Box 491013

Los Angeles, CA 90049

310.479.5982

CLIENT: The Fitness Choice

DESIGN FIRM: [i]e design, Los Angeles

ART DIRECTOR/ILLUSTRATOR: Marcie Carson

DESIGNERS: Marcie Carson / David Gilmour

CLIENT: Chuck Heiney Photography

DESIGN FIRM: Palazzolo Design Studio

ART DIRECTOR: Greg Palazzolo

DESIGNER: Troy Gough

SOFTWARE: Adobe Illustrator /
Adobe Photoshop

PAPER STOCK: Hammermill Via

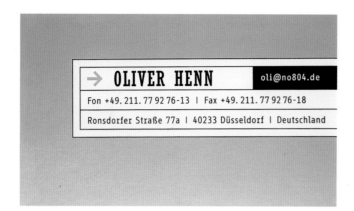

CLIENT: Designbüro no. 804

DESIGN FIRM: Designbüro no. 804

DESIGNERS: Helge Rieder / Oliver Henn /
Katja Scheid

SOFTWARE: Quark XPress

PAPER STOCK: Römerturm Colambo Gletscher

PRINTING: 3 colors

CLIENT: Anderson Thomas Design

DESIGN FIRM: Anderson Thomas Design

ART DIRECTOR: Joel Anderson

DESIGNER: Roy Roper

SOFTWARE: Adobe Photoshop /
Adobe Illustrator /
Quark XPress

PRINTING: 4-color process over 1 flood PMS

CLIENT: Gourmet's Choice Roasterie

DESIGN FIRM: LPG Design

ART DIRECTOR: Chris West

DESIGNER/ILLUSTRATOR: Lorna West

SOFTWARE: Macromedia Freehand

PAPER STOCK: Warrens Luster Cream Dull

AdamsMorioka

Sean Adams
370 South Doheny Drive, No. 201
Beverly Hills, California 90211
310 246 5758 tel • 310 246 0155 fax
sean@adamsmorioka.com

CLIENT: AdamsMorioka

DESIGN FIRM: AdamsMorioka

ART DIRECTOR/DESIGNER: Sean Adams

SOFTWARE: Adobe Illustrator

PAPER STOCK: 240 M Glo-Brite

AdamsMorioka

Philip B.
President

Home Office USA
P.O. Box 15341
Beverly Hills, CA
90209-1341

310 659 3066 tel.
800 643 5556 toll free
310 659 7742 fax
PBHair@aol.com

BOTANICAL HAIR CARE PRODUCTS

CLIENT: Philip B.

DESIGN FIRM: AdamsMorioka

ART DIRECTOR: Sean Adams

DESIGNER: Noreen Morioka

SOFTWARE: Adobe Illustrator

PAPER STOCK: UV Ultra Radiant White

Philip B. フィリップ B.
President 代表取締役

Home Office USA
P.O. Box 15341
Beverly Hills, CA
90209-1341

310 659 3066 tel.
800 643 5556 toll free
310 659 7742 fax
PBHair@aol.com

PHILIP B®
BOTANICAL HAIR CARE PRODUCTS

CLIENT: Rillke & Sandelmann Fotografie

DESIGN FIRM: Braue Branding &
Corporate Design

ART DIRECTOR/DESIGNER/ILLUSTRATOR:
Marcel Robbers

SOFTWARE: Adobe Illustrator / Quark XPress

PAPER STOCK: Profistar 300 g/qm

PRINTING: 2 colors / offset

Fred
fred@frederator.kz
(646) 487-6801

Frederator
◆◆◆◆◆◆◆◆◆◆ INCORPORATED ◆◆◆◆◆◆◆◆◆◆
711 THIRD AVENUE
19th floor
New York City
10017◆◆4014
www.frederator.kz

CLIENT: Fred Seibert

DESIGN FIRM: AdamsMorioka

ART DIRECTOR/DESIGNER: Sean Adams

SOFTWARE: Adobe Illustrator

PAPER STOCK: 240 M Glo-Brite

BOTTLEROCKET BEVERAGE RESOURCE

BOTTLEROCKET BEVERAGE RESOURCE LLC
P.O. BOX 6979 • NAPA, CA 94581
TEL: 707 253 2511 • FAX: 707 253 2515
PACBRENT@PACBELL.NET

BRENT SHORTRIDGE

CLIENT: BottleRocket Beverage Resource

DESIGN FIRM: Jim Moon Designs

ART DIRECTOR/DESIGNER: Jim Moon

ILLUSTRATORS: Tom Hennessy / Jim Moon

SOFTWARE: Adobe Illustrator / Quark XPress

SOFTWARE: Simpson Quest Ivory Cover

PRINTING: 5 passes of opaque white
and 4 PMS colors

A.C. GREEN
PRESIDENT

PO BOX 1709
PHOENIX, AZ 85001-1709
T 602.528.0790
F 602.528.0783
1.800.AC.YOUTH
WWW.ACGREEN.COM

CLIENT: A.C. Green Youth Foundation

DESIGN FIRM: Rule 29

ART DIRECTOR/DESIGNER/ILLUSTRATOR:
Justin Ahrens

SOFTWARE: Quark XPress / Adobe Illustrator

PAPER STOCK: Neenah Classic Crest Natural
White / 80 lb. Cover

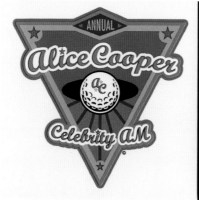

CLIENT: Solid Rock/Alice Cooper
Celebrity Golf Tourney

DESIGN FIRM: Rule 29

ART DIRECTOR/DESIGNER/ILLUSTRATOR:
Justin Ahrens

SOFTWARE: Quark XPress / Adobe Illustrator

PAPER STOCK: Oji Topkote Gloss / 80 lb. cover

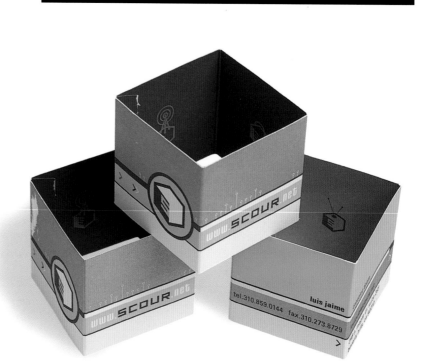

CLIENT: Scour.com

DESIGN FIRM: 44 Phases

ART DIRECTOR: Daniel H. Tsai

DESIGNERS/ILLUSTRATORS: Daniel H. Tsai /
Luis Jaime

SOFTWARE: Adobe Illustrator

PAPER STOCK: Neenah Classic Crest Solar
White Super Smooth / 80 lb.

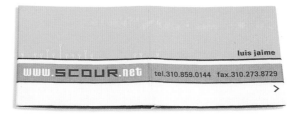

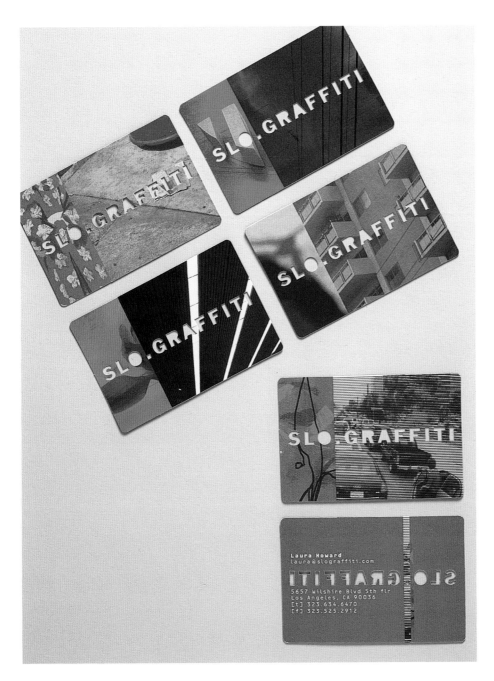

CLIENT: Slo Graffiti

DESIGN FIRM: 44 Phases

ART DIRECTOR: Daniel H. Tsai

DESIGNERS: Daniel H. Tsai /
Wolfgang Geramb /
Yoon Lee / Prances Torres /
Luis Jaime / Chalalai Haema

ILLUSTRATOR: Hiroko Tsuji

SOFTWARE: Adobe Illustrator

PAPER STOCK: Mohawk Superfine
Ultra White / 130 lb. cover

CATHERINE ROMAN: *CREATIVE DIRECTOR*

ROMANSON
DESIGN GROUP
11321 Iowa Avenue, Suite 11
Los Angeles, California 90025

310/966.9153 fax: 310/966.9154
[www.romansondg.com - cath@romansondg.com]

CLIENT: Romanson Design Group

DESIGN FIRM: Romanson Design Group

ART DIRECTOR/DESIGNER: Catherine Roman

SOFTWARE: Quark XPress /
Adobe Photoshop

PAPER STOCK: Neenah Classic Crest Duplex

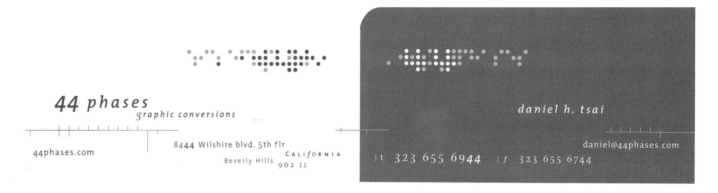

daniel h. tsai

daniel@44phases.com

| t 323 655 6944 | f 323 655 6744

yu tsai

yu-tsai@44phases.com

| t 323 655 6944 | f 323 655 6744

44 *phases*
graphic conversions

44phases.com

8444 Wilshire blvd. 5th flr
CALIFORNIA
Beverly Hills 902 11

daniel h. tsai

daniel@44phases.com

| t 323 655 6944 | f 323 655 6744

CLIENT: 44 Phases

DESIGN FIRM: 44 Phases

ART DIRECTOR: Daniel H. Tsai

DESIGNERS/ILLUSTRATORS: Daniel H. Tsai /
Luis Jaime

SOFTWARE: Adobe Illustrator

PAPER STOCK: McCoy / 120 lb. cover

josé eber
ATELIER

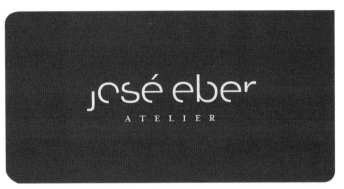

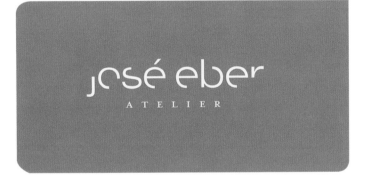

CORPORATE ADDRESS :
9460 Wilshire Blvd., Suite 320
Beverly Hills, CA 90212
joseeberatelier.com

p | 310 788 7799 f | 310 788 7797

CLIENT: José Eber Salon

DESIGN FIRM: 44 Phases

ART DIRECTOR: Daniel H. Tsai

DESIGNERS: Daniel H. Tsai /
Prances Torres / Luis Jaime

ILLUSTRATORS: Chalalai Haema /
Marco Pinsker

SOFTWARE: Adobe Illustrator

PAPER STOCK: McCoy / 120 lb. cover

CLIENT: Doug Baldwin

DESIGN FIRM: Oakley Design Studios

ART DIRECTOR/DESIGNER/ILLUSTRATOR:
Tim Oakley

SOFTWARE: Adobe Illustrator

PAPER STOCK: Neenah Classic Crest

CLIENT: Carbone Smolan Agency

DESIGN FIRM: Carbone Smolan Agency

ART DIRECTOR: Ken Carbone

DESIGNER: Martine Channon

SOFTWARE: Adobe Illustrator

PAPER STOCK: Starwhite Vicksburg /
Tiara Smooth

Ken Carbone

Carbone Smolan Agency
22 West 19th Street, 10th floor
New York, NY 10011 4204
tel 212 807 0011 fax 212 807 0870
ken@carbonesmolan.com
www.carbonesmolan.com

Gayle Gregory
archivist

Carbone Smolan Agency
22 West 19th Street, 10th floor
New York, NY 10011 4204
tel 212 807 0011 fax 212 807 0870
gayle@carbonesmolan.com
www.carbonesmolan.com

Brian Costello

t 212.331.8900

f 212.343.2134

e brian@thousand-words.com

www.thousand-words.com

601 W.26 Street 11th Floor
New York NY 10001

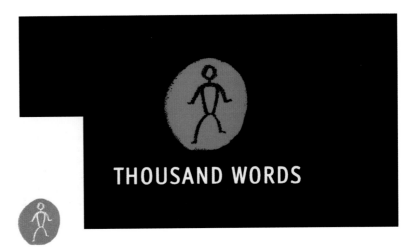

CLIENT: Thousand Words

DESIGN FIRM: Carbone Smolan Agency

ART DIRECTOR: Ken Carbone

DESIGNER/ILLUSTRATOR: Lesley Kunikis

SOFTWARE: Adobe Illustrator

PAPER STOCK: Fox River Coronado

Patricia G. Hambrecht
President

CHRISTIE'S

20 Rockefeller Plaza
New York, NY 10020
phone 212.636.2920
fax 212.636.4956

CLIENT: Christie's

DESIGN FIRM: Carbone Smolan Agency

ART DIRECTOR: Claire Taylor

DESIGNER: Koi Vantanapahu

SOFTWARE: Adobe Illustrator

722 Yorklyn Road
Suite 150
Hockessin, DE 19707
fax (302) 234-5705

www.theorbit.com

voice (302) 234-5700
extension 121
lisa.harris@theorbit.com

Lisa Harris

President and CEO

CLIENT: Orbit Integrated

DESIGN FIRM: Orbit Integrated

ART DIRECTOR/DESIGNER/ILLUSTRATOR:
Jack Harris

SOFTWARE: Adobe Illustrator

PAPER STOCK: Strathmore Ultimate White

PRINTING: 4-color process

CLIENT: Whirlegig, Inc.

DESIGN FIRM: Orbit Integrated

ART DIRECTOR: Jack Harris

DESIGNER/ILLUSTRATOR: Ed Abbott

SOFTWARE: Adobe Illustrator

PAPER STOCK: Strathmore Ultimate White

PRINTING: 2 colors

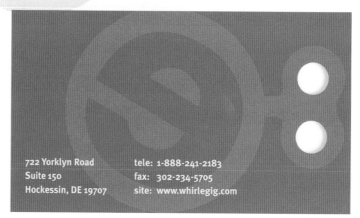

whirlegig™

Take your web site out for a spin.™

722 Yorklyn Road
Suite 150
Hockessin, DE 19707

tele: 1-888-241-2183
fax: 302-234-5705
site: www.whirlegig.com

John Giardino M.C.P.
IMPLEMENTATION CONSULTANT

RIMROCK CORPORATION

1210 Eglinton Avenue West
Toronto Ontario M6C 2E3
T) 416 256 4995 Ext.49
F) 416 256 4604
jgiardino@rimrock.com

CLIENT: Rimrock Corporation

DESIGN FIRM: Q30 Design Inc.

ART DIRECTOR: Glenda Rissman

DESIGNER: Jaspal Riyait

SOFTWARE: Quark XPress

PAPER STOCK: Fraser Pegasus

Kelli McDowell • Executive Producer
6561 Franklin Avenue, Hollywood, CA 90028
Phone 323 850 5522 Fax 323 850 5527
kelli@mirellafilm.com
www.mirellafilm.com

mirella Film Company

CLIENT: Mirella Film Company

DESIGN FIRM: Q30 Design Inc.

ART DIRECTOR: Glenda Rissman

DESIGNER: Jaspal Riyait

ILLUSTRATOR: Mary Pocock

SOFTWARE: Quark XPress

PAPER STOCK: Mohawk Navajo

WANTED: SPVA Seeks Adventurous Audience.

Brain Required.
(Jacket Optional)

Drama Queen Seeks Audience.

WANTED: Butts In Seats.

DANGER: Heavy Breathing May Occur.

You Can Come Alone.

619.235.8468
SPVA/20

344 7th avenue
san diego ca 92101

P 619 234 2061
F 619 234 2062

don hollis
senior craftsman

notes
....................................
....................................
....................................
....................................
....................................

always consult a trained professional

donh@hollisdesign.com

HOLLIS

344 7th avenue
san diego ca 92101

P 619 234 2061
F 619 234 2062

mark boydston
head chef

notes
....................................
....................................
....................................
....................................
....................................

bon appetit

markb@hollisdesign.com

HOLLIS

HOLLIS

CLIENT: Sushi Performance Theater

DESIGN FIRM: Hollis

ART DIRECTOR: Don Hollis

DESIGNER: Paul Drohan

SOFTWARE: Macromedia Freehand

PAPER STOCK: White / 120 lb. cover

PRINTING: 1 over 1

CLIENT: Hollis

DESIGN FIRM: Hollis

DESIGNER: Don Hollis

ILLUSTRATOR: Various

SOFTWARE: Macromedia Freehand

PAPER STOCK: Gloss White / 120 lb. cover

PRINTING: 4-color process both sides / die-cut
and perforated

HANS H. HÖRNER

Ambiana GmbH

Bahnhofstr. 4, D-85567 Grafing b. München *phone* +49 8092 818312 *fax* +49 8092 32168
mobile +49 172 8906149 *email* hoerner@i-dial.de

CLIENT: Ambiana GmbH

DESIGN FIRM: Equus Design Consultants P/L

ART DIRECTOR: Andrew Thomas

DESIGNER/ILLUSTRATOR: Rudi Boo

SOFTWARE: Adobe Illustrator /
Adobe Photoshop

PAPER STOCK: Curtis Retreeve Natural

PRINTING: 2 colors

JENNY SERCER.studio manager.

ADDRESS. king plow arts center. 887 west marietta street. studio t-102. atlanta. georgia. 30318.

TELEPHONE. 404.816.0094. FACSIMILE. 404.816.0095. EMAIL. jsercer@currentsite.com

CLIENT: Current, Inc.

DESIGN FIRM: Current, Inc.

ART DIRECTOR/DESIGNER: Wendy Sugarman

ILLUSTRATOR: Kelley Freeley

SOFTWARE: Adobe Illustrator / Quark XPress

PAPER STOCK: French Construction
Pure White / 100 lb.

City Hall
655 Main Street
Moncton
New Brunswick
Canada
E1C 1E8

Hôtel de Ville
655, rue Main
Moncton
Nouveau-Brunswick
Canada
E1C 1E8

Brian F.P. Murphy
Mayor / Maire

tel / tél 506 ▪ 856-4343
fax / télec 506 ▪ 853-3553
brian.murphy@moncton.org

MONCTON

CLIENT: Office of the Mayor, City of Moncton

DESIGN FIRM: In-house

DESIGNER: Judy Wheaton

SOFTWARE: Adobe Pagemaker /
Adobe Photoshop

PAPER STOCK: Utopia Premium

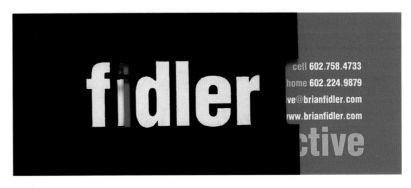

cell 602.758.4733
home 602.224.9879
ive@brianfidler.com
www.brianfidler.com
ctive

CLIENT: brianfidler interactive

DESIGN FIRM: brianfidler interactive

ART DIRECTOR/DESIGNER: Brian Fidler

SOFTWARE: Adobe Illustrator

PRINTING: Epson Color 1160 for internal piece

111

CLIENT: Free-Range Chicken Ranch

DESIGN FIRM: Free-Range Chicken Ranch

DESIGNERS: Kelli Christman / Toni Parmley

ILLUSTRATORS: Dave Parmley / Donna Gilbert

SOFTWARE: Quark XPress / Adobe Illustrator

PAPER STOCK: Fox River Sundance
Country Cream

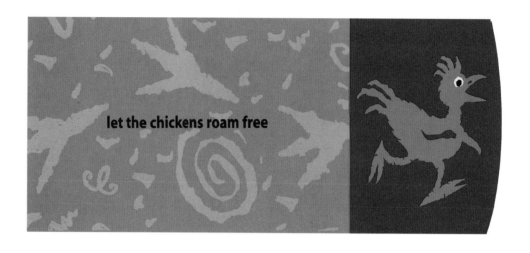

let the chickens roam free

go fish

with
Bob Starbody

fish
associates

office: 408.866.5044

fax: 408.866.5044

cell: 650.464.0117

email: jstarbody@aol.com
palm: jstarbody@palm.net
416 Lawndale Avenue
Campbell, CA 95008

CLIENT: Go Fish

DESIGN FIRM: Free-Range Chicken Ranch

ART DIRECTOR: Kelli Christman

DESIGNERS: Kelli Christman / Toni Parmley

ILLUSTRATOR: Toni Parmley

SOFTWARE: Quark XPress / Adobe Illustrator

PAPER STOCK: Starwhite Vicksburg /
130 lb. cover

CLIENT: Cedar Rapids Performance Company

DESIGN FIRM: Marketing and Communication Strategies, Inc.

DESIGNER/ILLUSTRATOR: Eric Dean Freese

SOFTWARE: Quark XPress / Adobe Illustrator

PAPER STOCK: Wausau Exact Color Copy White / 60 lb. cover

PRINTING: PMS 300 and PMS 185 / black digitally printed

CLIENT: Cheney & Company

DESIGN FIRM: Shane Lewis Design, Inc.

DESIGNER: Shane A. Lewis

SOFTWARE: Macromedia Freehand

PAPER STOCK: Starwhite Vicksburg

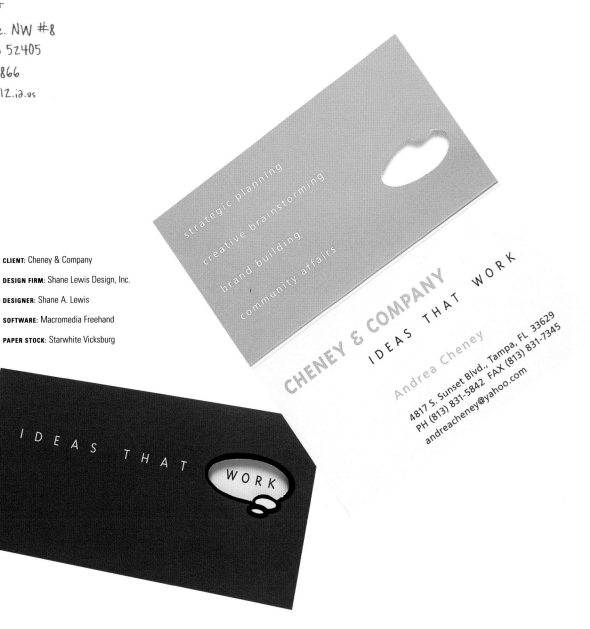

SEVELL + SEVELL INC.

Steven Jay Sevell
614.341.9700

fax 614.341.9701
www.sevell.com
sevell@sevell.com

240 North Fifth Street
Suite 200
Columbus, Ohio 43215

CLIENT: Sevell + Sevell, Inc.

DESIGN FIRM: Sevell + Sevell, Inc.

ART DIRECTOR/DESIGNER: Steven J. Sevell

SOFTWARE: Adobe Photoshop / Quark XPress

PAPER STOCK: Simpson Protocol Cover Plus / 88 lb.

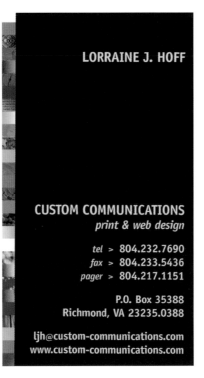

LORRAINE J. HOFF

CUSTOM COMMUNICATIONS
print & web design

tel > 804.232.7690
fax > 804.233.5436
pager > 804.217.1151

P.O. Box 35388
Richmond, VA 23235.0388

ljh@custom-communications.com
www.custom-communications.com

CLIENT: Custom Communications

DESIGN FIRM: Custom Communicaitons

ART DIRECTOR/DESIGNER: Lorraine J. Hoff

SOFTWARE: Quark XPress / Adobe Photoshop

PAPER STOCK: Gloss C2S 12 pt. cover

PRINTING: 4-color process

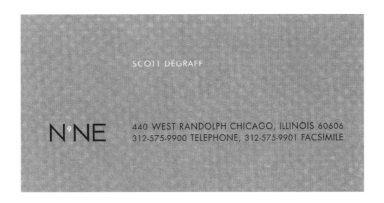

SCOTT DEGRAFF

N⁹NE 440 WEST RANDOLPH CHICAGO, ILLINOIS 60606
312-575-9900 TELEPHONE, 312-575-9901 FACSIMILE

CLIENT: Nine

DESIGN FIRM: Lowercase, Inc.

ART DIRECTOR/DESIGNER: Tim Bruce

SOFTWARE: Quark XPress

PAPER STOCK: Strathmore

PAUL W. EARLE, JR.
FOUNDER

COW TOWN GROUP, INC.
ONE NORTH DEARBORN STREET
SUITE 1300
CHICAGO, ILLINOIS 60602

312 606-2644 TELEPHONE
312 606-8101 FACSIMILE
EARLE@COWTOWNGROUP.COM

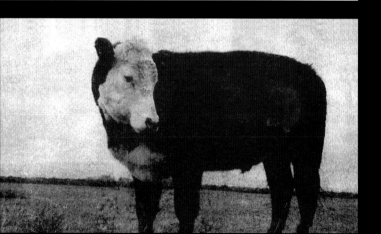

CLIENT: Mortensen Design

DESIGN FIRM: Mortensen Design

ART DIRECTOR/DESIGNER: Gordon Mortensen

SOFTWARE: Macromedia Freehand /
Quark XPress

PAPER STOCK: Somerset Velvet
Soft White 300 g.

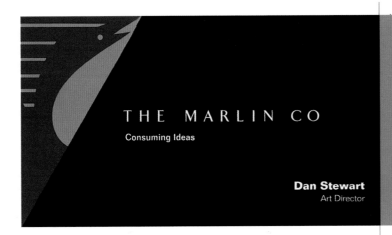

THE MARLIN CO

Consuming Ideas

Dan Stewart
Art Director

Dan Stewart
Art Director

1200 East Woodhurst, Building V
Springfield, Missouri 65804

417.887.7446
fax: 417.887.3643

http://www.**Marlin-Thing**.com

e-mail: elvis@Marlin-Thing.com

CLIENT: The Marlin Company

DESIGN FIRM: Fishhead Design

ART DIRECTOR/DESIGNER: Dan Stewart

SOFTWARE: Adobe Illustrator

PRINTING: Metallic inks

JIM GEIB
executive producer

twist

twist

4110 Pillsbury Avenue
Minneapolis MN 55409
tel | 612 822 3272
fax | 612 827 7062
email | twistjim@aol.com

FILM
PRODUCTIONS

CLIENT: Twist

DESIGN FIRM: Sussner Design Company

DESIGNER: Derek Sussner

MATERIALS: Stickers and stamps

CLIENT: Barton & Campbell

DESIGN FIRM: Sussner Design Company

ART DIRECTOR: Derek Sussner

DESIGNER: Ralph Schrader

CLIENT: Transcendent Training Products (TTP)

DESIGN FIRM: Sussner Design Company

ART DIRECTOR: Derek Sussner

DESIGNER: Ryan Carlson

CLIENT: Cliffside Entertainment

DESIGN FIRM: Sackett Design Associates

ART DIRECTOR: Mark Sackett

DESIGNERS: Audrey Gordon / George White

SOFTWARE: Adobe Photoshop / Quark XPress / Adobe Illustrator

PAPER STOCK: Mohawk Superfine Ultra White Eggshell

MAHA CAROTHERS

16 THOMPSON LANE

NEWARK, DE 19711-3220

302-731-7577

THE POST PRESS

CLIENT: Martha Carothers

DESIGN FIRM: The Post Press

ART DIRECTOR/DESIGNER: Martha Carothers

SOFTWARE: Quark XPress

PRINTING: Offset / colored pencil

CLIENT: Ego Communications

DESIGN FIRM: Ego Communications

ART DIRECTOR: Ève Legris

DESIGNER: Mathieu Larocque

SOFTWARE: Adobe Illustrator

PAPER STOCK: San Remo Plus

CLIENT: Aquarium Restaurant

DESIGN FIRM: Mirage Design

ART DIRECTOR/DESIGNER: Lynette Allaire

ILLUSTRATOR: Mark Daponte

SOFTWARE: Macromedia Freehand / Adobe Photoshop

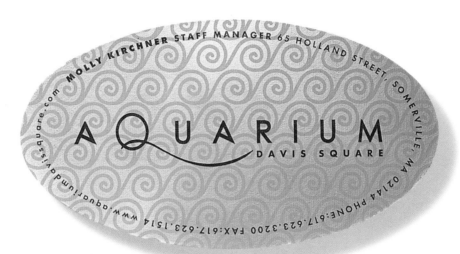

MOLLY KIRCHNER STAFF MANAGER 65 HOLLAND STREET, SOMERVILLE, MA 02144 PHONE:617.623.3200 FAX:617.623.1514 www.aquariumdavissquare.com

AQUARIUM
DAVIS SQUARE

ADMIT ONE BEFORE 10 (21+)

11 Park Street Brookline MA 02446 P 617.264.2862 F 617.264.2861

Nélida Nassar
nnassar@shore.net

NASSAR DESIGN

CLIENT: Nassar Design

DESIGN FIRM: Nassar Design

ART DIRECTOR: Nelida Nassar

DESIGNER: Margarita Encomienda

SOFTWARE: Adobe Illustrator / Quark XPress

PAPER STOCK: Thibierge et Covar Cromatica

PRINTING: Silkscreened

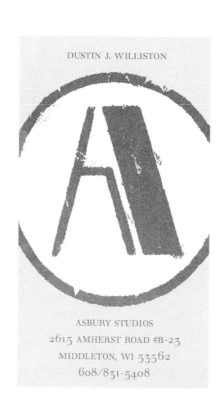

DUSTIN J. WILLISTON

ASBURY STUDIOS
2615 AMHERST ROAD #B-23
MIDDLETON, WI 53562
608/831-5408

CLIENT: Asbury Studios

DESIGN FIRM: Asbury Studios

ART DIRECTOR/DESIGNER:
Dustin J. Williston

SOFTWARE: Adobe Photoshop /
Quark XPress /
Adobe Illustrator

PAPER STOCK: Neenah Classic Crest

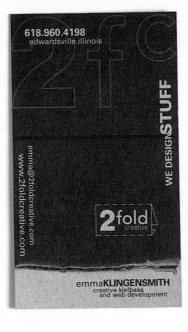

CLIENT: 2fold Creative

DESIGN FIRM: 2fold Creative

ART DIRECTOR: Emma Klingensmith

DESIGNER: Bill Klingensmith

SOFTWARE: Adobe Photoshop / Adobe Illustrator

PAPER STOCK: Georgia-Pacific Proterra Antique Kraft / 80 lb. cover

CLIENT: Avonlea

DESIGN FIRM: Design Center

ART DIRECTOR: John Reger

DESIGNER: Sherwin Schwartzrock

SOFTWARE: Macromedia Freehand

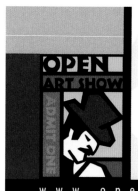

CLIENT: Open Art Show

DESIGN FIRM: X Design Company

ART DIRECTOR/DESIGNER: Alex Valderrama

CLIENT: EventSmiths

DESIGN FIRM: X Design Company

ART DIRECTOR/DESIGNER: Alex Valderrama

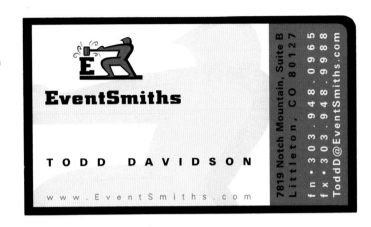

CLIENT: Elements LLC

DESIGN FIRM: Elements, LLC

ART DIRECTOR/DESIGNER: Amy Wentworth

PAPER STOCK: Neenah Classic Crest
Solar White / 80 lb.

AMY WENTWORTH

GRAPHIC DESIGNER

ELEMENTS, LLC

28 SUMMIT ROAD

HAMDEN, CT 06514

TEL: 203.407.1323

FAX: 203.407.0133

WEBSITE: ELEMENTS4.COM

ELEMENTS

AMY WENTWORTH

GRAPHIC DESIGNER

ELEMENTS, LLC

28 SUMMIT ROAD

HAMDEN, CT 06514

TEL: 203.407.1323

FAX: 203.407.0133

WEBSITE: ELEMENTS4.COM

ELEMENTS

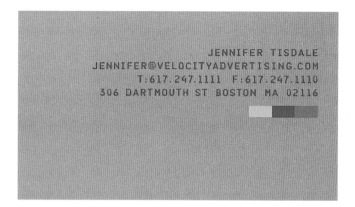

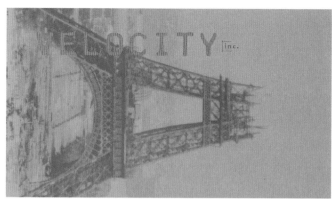

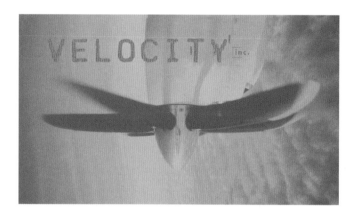

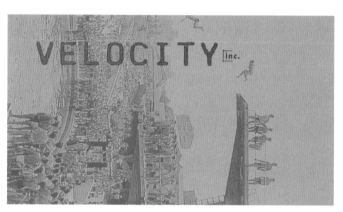

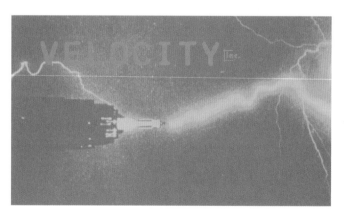

CLIENT: Velocity Advertising

DESIGN FIRM: Velocity Advertising

ART DIRECTOR: Sandi Quatrale

CREATIVE DIRECTOR: Lisa Hickey

SOFTWARE: Quark Xpress

PAPER STOCK: Strathmore Recycled Soft White

PRINTING: Metallic duotone / 4 neon colors

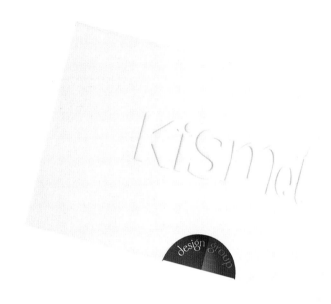

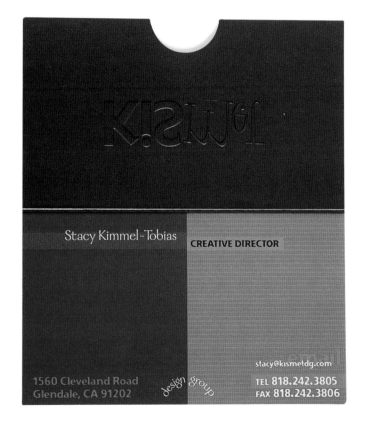

CLIENT: Kismet Design Group, LLC

DESIGN FIRM: Kismet Design Group, LLC

ART DIRECTORS: Anet Khayat / Stacy Kimmel

SOFTWARE: Quark XPress / Adobe Illustrator

PAPER STOCK: Neenah Classic Crest

PRINTING: 3 colors / blind-embossed / die-cut / folded

CLIENT: Imagenus Inc.

DESIGN FIRM: Kismet Design Group, LLC

ART DIRECTORS: Anet Khayat / Stacy Kimmel

SOFTWARE: Quark XPress / Adobe Illustrator

PAPER STOCK: McCoy

PRINTING: 3 over 3 / die-cut

Yvette K Yessayantz *President & CEO*

655 N. Central Avenue • Suite 1748
Glendale • California 91203

Phone 818.649.7674 Fax 818.649.8256
Email yvette@imagenusinc.com
www.imagenusinc.com

CLIENT: Euroarte

DESIGN FIRM: Planet Propaganda

ART DIRECTOR: Kevin Wade

DESIGNER: Brad DeMarea

PRINTING: Letterpressed

E

PETER ALEXANDER

EUROARTE
1360 REGENT STREET, SUITE 192
MADISON, WISCONSIN 53715
PHONE 800.351.7723
CELL 608.212.1712
FAX 608.245.9743

EuroArte

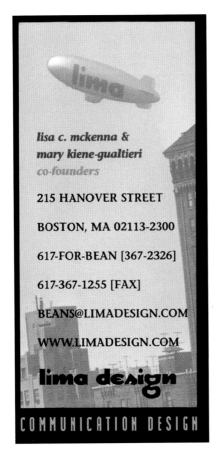

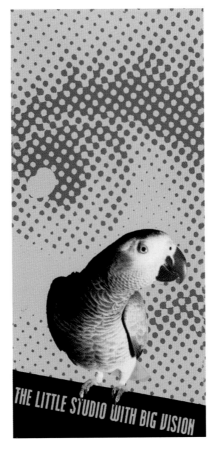

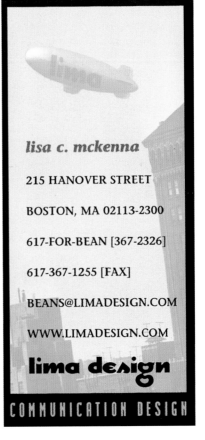

CLIENT: Lima Design

DESIGN FIRM: Lima Design

DESIGNERS: Mary Keine-Gualtieri /
Lisa McKenna

SOFTWARE: Adobe Photoshop / Quark XPress

PAPER STOCK: Bird Model Tallulah

BLACKCOFFEE DESIGN® INC.
BLACKCOFFEEDESIGN.COM

[840 SUMMER STREET
BOSTON MASS 02127
TEL: [617] 268.1116
FAX: [617] 268.2259

CLIENT: Turner and Associates

DESIGN FIRM: Turner and Associates

ART DIRECTOR: Phil Hamlett

DESIGNERS: Laurie Carrigan / Laura Milton

SOFTWARE: Quark XPress

PAPER STOCK: Crane's Kid Finish
Pearl White / 134 lb. cover

PRINTING: Letterpressed 1 over 1 /
lithographed 1 over 1

CLIENT: Blackcoffee Design Inc.

DESIGN FIRM: Blackcoffee Design Inc.

DESIGNERS: Mark Gallagher / Laura Savard

SOFTWARE: Adobe Illustrator

PAPER STOCK: Lexan

PRINTING: Silkscreened

Stephen Turner
CEO and Executive Creative Director
415 344 0990 x329
steve@turnersf.com

worst of times >

Turner & Associates
577 Second Street, Studio 204
San Francisco, California 94107
415 344 0990 v
415 344 0991 f
www.turnersf.com

best of times >

Stephen Turner
CEO and Executive Creative Director
415 344 0990 x329
steve@turnersf.com

fury >

Turner & Associates
577 Second Street, Studio 204
San Francisco, California 94107
415 344 0990 v
415 344 0991 f
www.turnersf.com

sound >

R.SEAGRAVES

364 Devon Drive San Rafael California 94903
phone 415.499.8680 *web* www.rseagraves.com
fax 415.499.8672 *email* shooter@rseagraves.com

R.SEAGRAVES

364 Devon Drive San Rafael California 94903
phone 415.499.8680 *web* www.rseagraves.com
fax 415.499.8672 *email* shooter@rseagraves.com

CLIENT: Richard Seagraves

DESIGN FIRM: Elixir Design

ART DIRECTOR: Jennifer Jerde

DESIGNER: Jennifer Tolo

SOFTWARE: Adobe Illustrator

PAPER STOCK: Crane's Kid Finish
 Pearl White / 90 lb. cover

PRINTING: 1 color lithography / embossed /
 die-cut

CLIENT: Castor-Henig Architecture

DESIGN FIRM: Elixir Design

ART DIRECTOR: Jennifer Jerde

DESIGNER: Holly Holmquist

SOFTWARE: Adobe Illustrator

PAPER STOCK: Fabriano Ellerre 220 gsm
Dark Grey cover

PRINTING: 1 color engraved / duplex

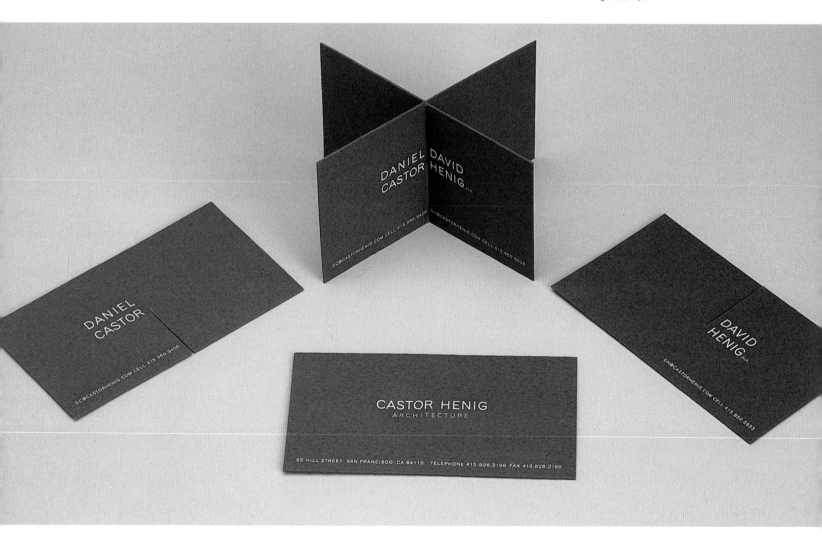

CLIENT: You Send Me

DESIGN FIRM: You Send Me

ART DIRECTORS/DESIGNERS: Jenni Bastone /
Karen Betz

SOFTWARE: Macromedia Freehand

PAPER STOCK: Fabriano Elle Erre 220 gsm
Onice (cream) cover

CLIENT: Suzanne George Shoes

DESIGN FIRM: Elixir Design

ART DIRECTOR: Jennifer Jerde

DESIGNER: Holly Holmquist / Nathan Durrant

ILLUSTRATOR: Tom Hennessy

SOFTWARE: Adobe Illustrator

PAPER STOCK: Fabriano Murillo
Pistachio Cover

PRINTING: 0 over 1 lithography /
2 over 0 letterpress /
embossed

CLIENT: Elixir Design

DESIGN FIRM: Elixir Design

ART DIRECTOR: Jennifer Jerde

DESIGNERS: Nathan Durrant /
Holly Holmquist /
Jennifer Tolo

SOFTWARE: Adobe Illustrator

PAPER STOCK: Stonehenge

PRINTING: 1 over 2 lithography /
blind-embossed

Neuhausen ob Eck

Gasthaus Adler
Familie Lang

Stockacher Str. 11
78579 Neuhausen ob Eck

Tel. 07467/405
Fax 07467/910678

ADLER

Neuhausen ob Eck

Familienfeiern
Vereinsfeiern
Nebenzimmer mit 40 Plätzen
Feiern bis zu 80 Personen
Biergarten im Sommer

Öffnungszeiten
10 bis 24 Uhr
Donnerstags Ruhetag

CLIENT: Gasthaus Adler

DESIGN FIRM: revoLUZion — Studio für Design

DESIGNER: Bernd Luz

SOFTWARE: Macromedia Freehand

CLIENT: Historic Development Leasing Corp.

DESIGN FIRM: Refinery Design Co.

ART DIRECTOR: Daniel Schmalz

SOFTWARE: Macromedia Freehand

MARK RETTENMAIER
1100 LINCOLN AVENUE
DUBUQUE. IA 52001-2138
319-588-3449 • hdlc@dubuque.net

CLIENT: Dzine Wise Design Studio

DESIGN FIRM: Dzine Wise
Design Studio

ART DIRECTOR/DESIGNER:
Mike Keating

SOFTWARE: Adobe Illustrator /
Quark Xpress

PAPER STOCK: Mirage Gloss / 100 lb. cover /
satin varnish

PRINTING: 4-color process 2 sides

DUCKS DON'T KNOW QUACK
ABOUT GREAT DESIGN,
AND DESIGNERS CAN'T FLY,
SO WE'RE EVEN.

MIKE KEATING DESIGNER
DZINE WISE DESIGN STUDIO
319/588/4747
mike@dzinewise.com
www.dzinewise.com
PO Box 3116/Dubuque/IA 52004

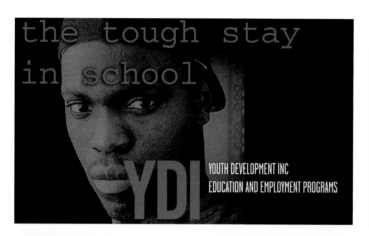

CLIENT: Youth Development Inc.

DESIGN FIRM: Vaughn Wedeen Creative

ART DIRECTOR/DESIGNER: Steve Wedeen

PRODUCTION ARTIST: Chip Wyly

SOFTWARE: Adobe Photosho / Quark XPress

PAPER STOCK: Utopia One Dull / 80 lb. cover

• ◗ ◖ ◖ ○

cynthia **eggers**
principal/designer

voice 770-978-0116
fax 770-978-6161
1523 napier terrace
lawrenceville ga 30044
www.moonlitcreative.com
info@moonlitcreative.com

CLIENT: Moonlit Creative Group

DESIGN FIRM: Moonlit Creative Group

ART DIRECTOR/DESIGNER: Cynthia Eggers

SOFTWARE: Adobe Photoshop /
Adobe Illustrator

PAPER STOCK: Karma White cover

PRINTING: 2 hits of black on front over black

Objets Curieux et Rares

1425 NORTHEAST BROADWAY
PORTLAND, OREGON 97212
TÉL: 503.284.3720

Objets Curieux et Rares

CLIENT: City of Paris

DESIGN FIRM: Design Infinitum

ART DIRECTOR/DESIGNER/ILLUSTRATOR:
James A. Smith

SOFTWARE: Adobe Illustrator

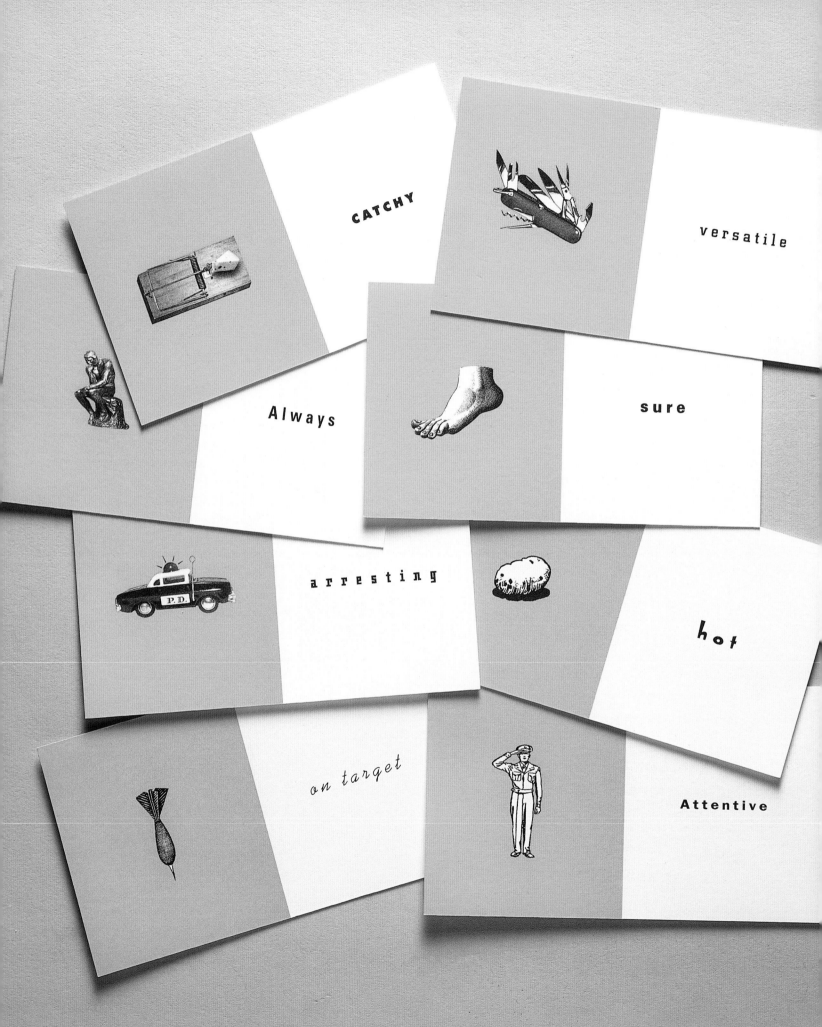

CATCHY

versatile

Always

sure

arresting

hot

on target

Attentive

vaughn wedeen creative

Christy Kay Lopez

email **cklopez@vwc.com**

407 rio grande nw albuquerque nm 87104

tel **505 243 4000** mob **505 259 9029**

fax **505 247 9856** web **www.vwc.com**

CLIENT: Vaughn Wedeen Creative

DESIGN FIRM: Vaughn Wedeen Creative

ART DIRECTORS: Rick Vaughn / Foster Hurley

DESIGNERS: Rick Vaughn

PRODUCTION ARTIST: Stan McCoy

SOFTWARE: Quark XPress / Adobe Photoshop

PAPER STOCK: Mohawk Superfine
Ultra White / 80 lb.

CLIENT: Candra Scott & Anderson

DESIGN FIRM: Elixir Design

ART DIRECTOR: Jennifer Jerde

DESIGNER/ILLUSTRATOR: Nathan Durrant

SOFTWARE: Adobe Illustrator

PAPER STOCK: Gmund Colors 300 gsm/28 /
Curtis Performance Blotter
Brown 100 lb. /
MACtac StarLiner Recycled
Uncoated Vellum White 70 lb.

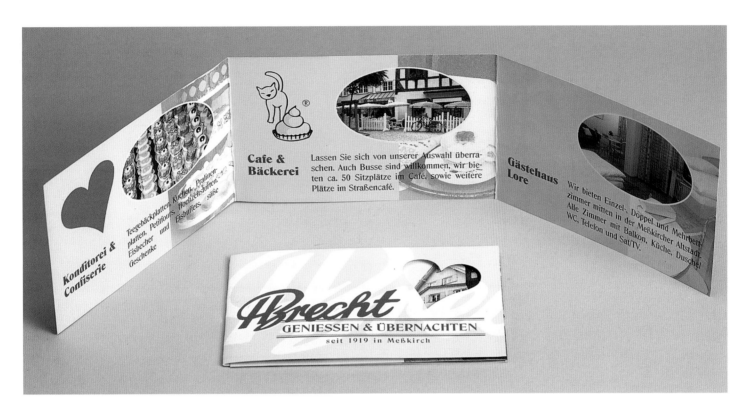

CLIENT: Konditorei & Café Brecht

DESIGN FIRM: revoLUZion-Studio für Design

DESIGNER: Bernd Luz

SOFTWARE: Quark XPress /
Adobe Photoshop /
Macromedia Freehand

CLIENT: Marcoz

DESIGN FIRM: Nassar Design

ART DIRECTOR/DESIGNER: Nelida Nassar

SOFTWARE: Quark XPress / Adobe Illustrator

PAPER STOCK: Strathmore Fiesta Deckle Edge

PRINTING: Offset

Marc S. Glasberg

Boston Design Center
One Design Center Place
Suite 328
Boston, MA 02210
617 357 · 0211

177 Newbury Street
Boston, MA 02116
617 262 · 0780

CLIENT: Tessuti di Montefalco S.r.l.

DESIGN FIRM: Studio GT & P

ART DIRECTOR: Gianluigi Tobanelli

SOFTWARE: Macromedia Freehand /
Adobe Photoshop

PAPER STOCK: Fedrigoni

PRINTING: 4-color process

CLIENT: Interpix Design Inc.

DESIGN FIRM: The Riordon Design Group Inc.

ART DIRECTOR: Dan Wheaton

DESIGNER: Alan Krpan

SOFTWARE: Quark XPress, Adobe Illustrator

PAPER STOCK: Neenah Classic Crest
Solar White

PRINTING: Circular die-cut

CLIENT: 37 Signals

DESIGN FIRM: Segura Inc.

ART DIRECTOR/DESIGNER: Carlos Segura

SOFTWARE: Adobe Illustrator

PRINTING: Letterpress

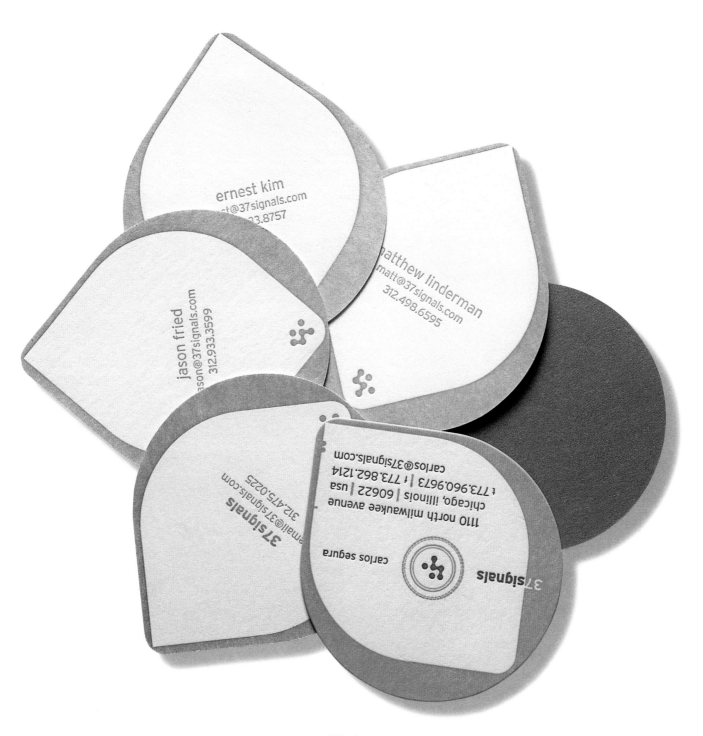

CLIENT: 37 Signals

DESIGN FIRM: Segura Inc.

ART DIRECTOR/DESIGNER: Carlos Segura

SOFTWARE: Adobe Illustrator

PRINTING: Letterpress

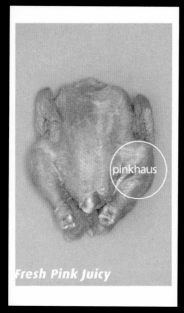

Fresh Pink Juicy

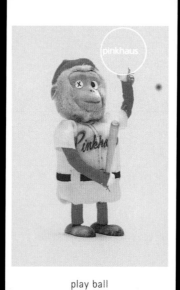

play ball

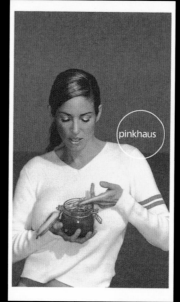

founder

pinkhaus

305.854.1000 *JOEL.FULLER* @ pinkhaus.com

CLIENT: Pinkhaus Design

DESIGN FIRM: Pinkhaus Design

ART DIRECTORS: Joel Fuller / Todd Houser

DESIGNERS: Todd Houser / Raelene Mercer

ILLUSTRATOR: John Westmark

PHOTOGRAPHER: Michael Dakota

PAPER STOCK: Gilbert Neutech Smooth
Light Cream / 120 lb. cover

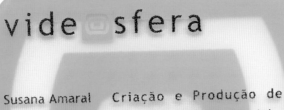

CLIENT: Videosfera

DESIGN FIRM: MA&A–Mário Aurélio
& Associados

ART DIRECTOR: Mário Aurélio

DESIGNER: Sónia Andrade

SOFTWARE: Macromedia Freehand

PRINTING: Silkscreened

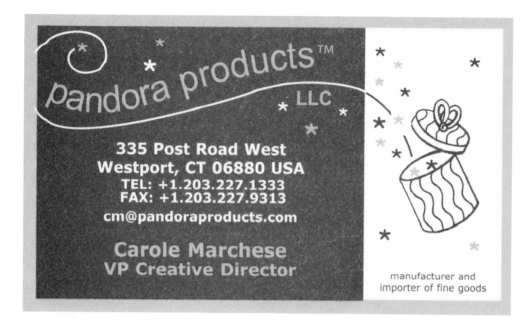

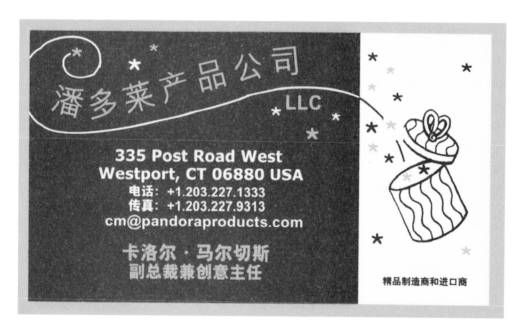

CLIENT: Pandora Products™, LLC

DESIGN FIRM: Red Bee® Studio

ART DIRECTOR/DESIGNER/ILLUSTRATOR:
Carole Marchese

SOFTWARE: Quark XPress / Adobe Photoshop

PAPER STOCK: Neenah Card Stock

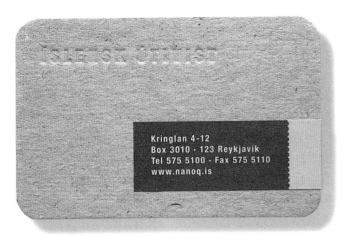

CLIENT: Nanoq

DESIGN FIRM: Gott Folk McCann-Erickson

ART DIRECTOR/DESIGNER: Einar Gylafason

SOFTWARE: Macromedia Freehand

PAPER STOCK: Eskaboard 1 mm

CLIENT: Yuzu Catering

DESIGN FIRM: Dynamo

DESIGNER: Brian Nolan

SOFTWARE: Adobe Illustrator / Quark Xpress

CLIENT: 9Volt Visuals

DESIGN FIRM: 9Volt Visuals

ART DIRECTOR/DESIGNER/ILLUSTRATOR:
Bobby June

SOFTWARE: Flash / Adobe Illustrator /
Adobe Photoshop

MATERIALS: Plastic

CLIENT: DGWB

DESIGN FIRM: DGWB

DESIGN DIRECTOR: Jonathan Brown

DESIGNER: Jason Simon

SOFTWARE: Adobe Illustrator

tnop
tnop@segura-inc.com www.segura-inc.com

1110 north milwaukee avenue
chicago, illinois 60622.4017 usa
773.862.5667 w 773.862.1214 f
312.320.0350 c

CLIENT: Segura Inc.

DESIGN FIRM: Segura Inc.

ART DIRECTOR/DESIGNER: Carlos Segura

SOFTWARE: Adobe Photoshop /
Adobe Illustrator

MATERIALS: Plastic

PRINTING: 4-color process

ELLIPSIS RESTAURANT

503 College Street West, Toronto TEL 929.2892 FAX 929.6135

ELLIPSIS BAKERY TAKE-OUT CATERING

CLIENT: Ellipsis

DESIGN FIRM: Dinnick & Howells

ART DIRECTOR: Jonathan Howells

DESIGNER: Nadine Classe

SOFTWARE: Adobe Illustrator /
Adobe Photoshop

PAPER STOCK: Pegasus Coated / 80 lb. cover

PRINTING: Lithographed

Peter Templeton, Patti Templeton

TEMPLETON
Fine Carpets

160 Pears Avenue, Suite 310
Toronto, Ontario M5R 3P8

Tel 416 923 2147
Fax 416 923 2477

Peter Templeton, Patti Templeton

TEMPLETON
Fine Carpets

160 Pears Avenue, Suite 310
Toronto, Ontario M5R 3P8

Tel 416 923 2147
Fax 416 923 2477

Peter Templeton, Patti Templeton

TEMPLETON
Fine Carpets

160 Pears Avenue, Suite 310
Toronto, Ontario M5R 3P8

Tel 416 923 2147
Fax 416 923 2477

CLIENT: Portfolio Entertainment

DESIGN FIRM: Dinnick & Howells

ART DIRECTOR/DESIGNER: Sarah Dinnick

SOFTWARE: Adobe Illustrator /
Adobe Photoshop

PAPER STOCK: Mohawk Vellum
Cool White / 80 lb. cover

PRINTING: Lithographed

PORTFOLIO
ENTERTAINMENT

CLIENT: Imbue

DESIGN FIRM: Sara Nelson Design, Ltd.

ART DIRECTOR: Sara Nelson

DESIGNER: Amie Lerch

SOFTWARE: Macromedia Freehand

PRINTING: Color photocopy

The Focus Is You

Terry Marie Fleischman • Owner/Director

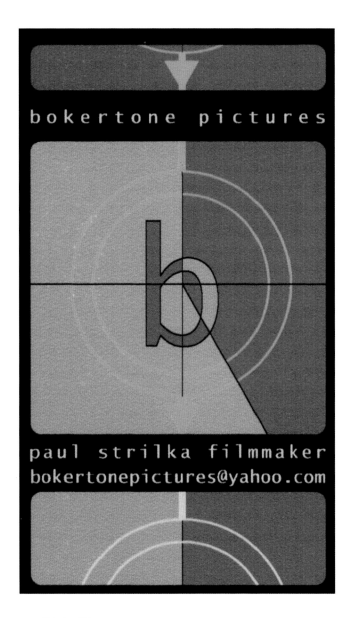

CLIENT: Bokertone Pictures

DESIGN FIRM: Satellite Graphics

ART DIRECTOR/DESIGNER/ILLUSTRATOR:
Steve Csejka

SOFTWARE: Adobe Illustrator

PAPER STOCK: Kodak photo paper

PRINTING: 4 colors / full-bleed

CLIENT: Pierce Design

DESIGN FIRM: Pierce Design

SOFTWARE: Macromedia Freehand

PAPER STOCK: Dessert Hase Vellum Double
Concept / 80 lb. cover

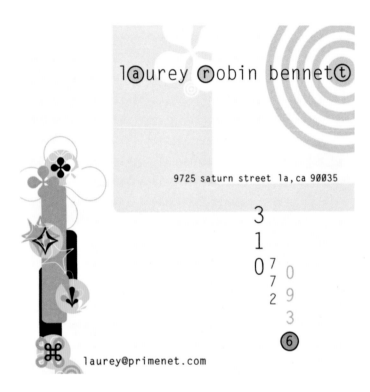

l@urey ®obin bennet(t)

9725 saturn street la, ca 90035

3
1
0 7
7 0
2 9
3
(6)

laurey@primenet.com

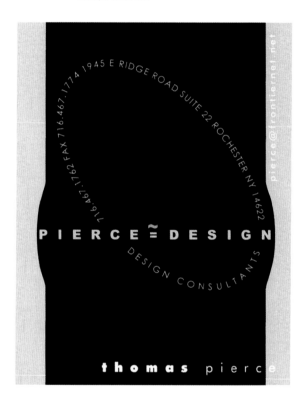

CLIENT: Laurey Robin Bennett Design

DESIGN FIRM: Laurey Robin Bennett Design

ART DIRECTOR/DESIGNER: Laurey Bennett

SOFTWARE: Adobe Illustrator / Quark XPress

PAPER STOCK: Strathmore

CLIENT: Douglas Oliver Design Office

DESIGN FIRM: Douglas Oliver Design Office

ART DIRECTOR: Douglas Oliver

DESIGNER: Clare McClaren

SOFTWARE: Quark XPress

PAPER STOCK: Crane's Fluorescent
White / 110 lb. cover

KRISTY ANN KUTCH

Colored Pencil Art/Instruction
11555 West Earl Road
Michigan City, IN 46360

(219) 874-4688
e-mail: kakutch@niia.net

Glorious Morning©, 16" x 20"

CLIENT: Kristy Ann Kutch Colored Pencil
Art/Instruction

DESIGN FIRM: Kristy Ann Kutch Colored Pencil
Art/Instruction

ILLUSTRATOR: Kristy Ann Kutch

CLIENT: So Design Pty Ltd.

DESIGN FIRM: So Design Pty Ltd.

ART DIRECTOR: Jacqui Thomas

SOFTWARE: Adobe Illustrator

PAPER STOCK: Raleigh Superfine Ultra White
Smooth 350 gsm

PRINTING: 2 colors / embossed

STEVE KYFFIN
GROUP MANAGING DIRECTOR

steve@bluestone.co.uk
BRISTOL 0117 905 8740
PLYMOUTH 01752 671783

IAN GUNNINGHAM
GROUP CREATIVE DIRECTOR

ian@bluestone.co.uk
BRISTOL 0117 905 8740
PLYMOUTH 01752 671783

MARK NORBURY
CREATIVE DIRECTOR

mark@bluestone.co.uk
BRISTOL 0117 905 8740
PLYMOUTH 01752 671783

NEIL BENNETT
STUDIO MANAGER

neil@bluestone.co.uk
BRISTOL 0117 905 8740
PLYMOUTH 01752 671783

SPENCER CONWAY
NEW MEDIA MANAGER

spencer@bluestone.co.uk
BRISTOL 0117 905 8740
PLYMOUTH 01752 671783

CLIENT: Bluestone

DESIGN FIRM: Bluestone

ART DIRECTOR/DESIGNER/ILLUSTRATOR:
Ian Gunningham

SOFTWARE: Macromedia Freehand

MATERIAL: Clear Plastic with Opaque Varnish

CLIENT: Vinski Konvent SV. Urbana

DESIGN FIRM: KROG

ART DIRECTOR/DESIGNER: Edi Berk

SOFTWARE: Quark XPress / Adobe Illustrator

PAPER STOCK: Conqueror

PRINTING: Offset

CLIENT: Vipi

DESIGN FIRM: KROG

ART DIRECTOR/DESIGNER: Edi Berk

SOFTWARE: Quark XPress / Adobe Illustrator

PAPER STOCK: Conqueror

PRINTING: Offset

**Izobraževalni
center**
Združenja bank Slovenije
Kongresni trg 4, 1000 Ljubljana
tel.: 01/42 52 114, 42 52 651
faks: 01/42 55 440
e-pošta: majda.sali@zbs-giz.si

Majda Šali, *univ. prof. psih.*
vodja Izobraževalnega centra

CLIENT: Zdruzenje Bank Solovenije

DESIGN FIRM: KROG

ART DIRECTOR/DESIGNER: Edi Berk

SOFTWARE: Quark XPress / Adobe Illustrator

PAPER STOCK: Conqueror

PRINTING: Offset

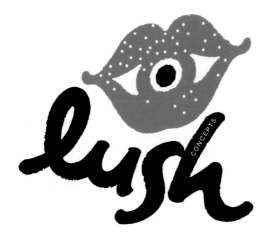

LUSH CONCEPTS

SIMON DENTON MICHELLE BOWEN

7/10 THE AVENUE PRAHRAN MELBOURNE

VICTORIA 3181 AUSTRALIA

PO BOX 2222 PRAHRAN MELBOURNE

VICTORIA 3181 AUSTRALIA

FACSIMILE 03) 510 3815 TELEPHONE 03) 510 3815

MOBILE 041 111 0217

CLIENT: Lush Concepts

DESIGN FIRM: Emery Vincent Design

ART DIRECTOR: Garry Emery

DESIGNERS: Emery Vincent Design Team

SOFTWARE: Adobe Photoshop /
Adobe Illustrator

Julian Vagg

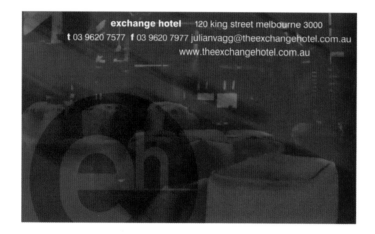

CLIENT: Exchange Hotel

DESIGN FIRM: Emery Vincent Design

ART DIRECTOR: Garry Emery

DESIGNERS: Emery Vincent Design Team

SOFTWARE: Adobe Photoshop /
Adobe Illustrator

SHOP 26 PRAN CENTRAL
CATO STREET
PRAHRAN VICTORIA 3181 AUSTRALIA
TELEPHONE 9510 8788
FACSIMILE 9510 8799

CLIENT: Kin Kao Restaurant

DESIGN FIRM: Emery Vincent Design

ART DIRECTOR: Garry Emery

DESIGNERS: Emery Vincent Design Team

SOFTWARE: Adobe Photoshop /
Adobe Illustrator

CLIENT: Black Rocket

DESIGN FIRM: Black Rocket

ART DIRECTORS: Steve Stone / Bob Kerstetter

SOFTWARE: Quark XPress

PAPER STOCK: Classic Columns Goldenrod /
Red / Blue cover

PRINTING: Letterpress

CLIENT: Fuel Design

DESIGN FIRM: Fuel Design

ART DIRECTORS/DESIGNERS: Stephanie Garrison /
Bryant Cole

SOFTWARE: Quark XPress / Adobe Illustrator

PAPER STOCK: French Construction Fuse Green

CLIENT: Chan Sau Fei

DESIGN FIRM: Kan & Lau
Design Consultants

ART DIRECTOR/DESIGNER: Kan Tai-Keung

ILLUSTRATORS: Students of Chan Sau Fei

SOFTWARE: Macromedia Freehand /
Adobe Photoshop

靳陳秀菲

兒童畫導師

Sophia Kan
Children Art Teacher

9A, Juniper Mansion, Tai Koo Shing, Hong Kong Tel: 2568 4065 Mobile: 9187 0088

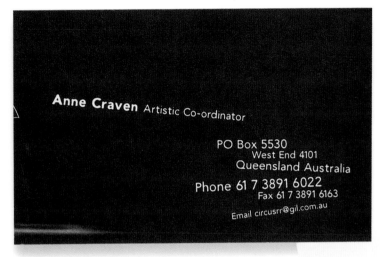

Anne Craven Artistic Co-ordinator

PO Box 5530
West End 4101
Queensland Australia

Phone 61 7 3891 6022
Fax 61 7 3891 6163

Email circusrr@gil.com.au

CLIENT: Rock 'n' Roll Circus

DESIGN FIRM: Inkahoots

ART DIRECTOR: Steven Alexander

DESIGNER: Robert Moore

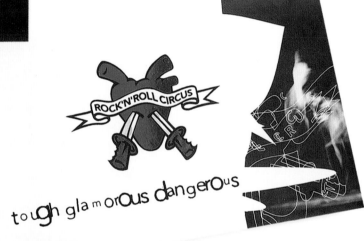

CREATORBANK
a fund exclusively for children and young people in care
to pursue social, recreational, educational and life opportunities
CREATE
contemporary, fun and informative magazine published
for and by children and young people in care
CREATE ONLINE
fully interactive set of online services connecting children and
young people in care in Australia and globally

THE CREATORSHIPS PROGRAM
self development and training in mentoring,
advocacy, presentation, leadership and the arts for 14-18 year olds in care
CREATE CONSULTING
consumer training and consulting services; research into
care issues and a policy base for CREATE work
CREATE LIVE!
exciting camps program which will reach out to children in care
in regional and rural areas of Australia twice a month

The Creatorships Program > Create Consulting > Create Live! 1800 655 105
Creatorbank > Create > Create Online 1800 354 134
CREATE
Adelaide ph 08 8212 8055 fax 08 8212 8066 Perth ph 08 9497 3604 fax 08 9497 4340 Canberra ph 02 6232 6135 fax 02 6295 9944 Darwin ph 08 8945 7751 fax 08 8945 7752
Sydney ph 02 9635 8833 fax 02 9635 8700 Melbourne ph 03 9614 0439 fax 03 9614 1774 Brisbane ph 07 3229 7905 fax 07 3229 7152

CLIENT: Create Foundation

DESIGN FIRM: Inkahoots

ART DIRECTOR: Russel Kerr

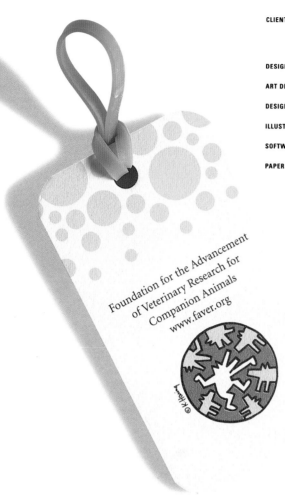

CLIENT: Foundation for the Advancement
of Veterinary Research for
Companion Animals (FAVeR)

DESIGN FIRM: Mirko Ilić Corp.

ART DIRECTOR: Mirko Ilić

DESIGNERS: Mirko Ilić / Heath Hinegarder

ILLUSTRATOR: Kieth Haring

SOFTWARE: Adobe Illustrator / Quark XPress

PAPER STOCK: Crane's

CLIENT: Edgar G. Praus, Photography

DESIGN FIRM: Zebra Design

ART DIRECTOR/DESIGNER: James L. Selak

SOFTWARE: Macromedia Freehand /
Quark XPress

PAPER STOCK: UV Ultra II / Columns

PRINTING: Offset

● by EDGAR G PRAUS
the fine art
of photography
15 church street
leroy , new york
1 4 4 8 2
p 716 . 768 . 8354
f 716 . 442 . 7124

photography
with the
presence of people
without people

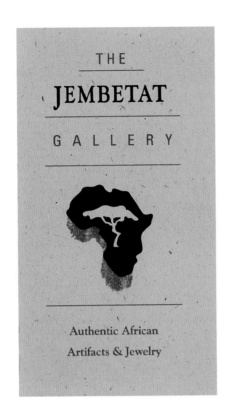

THE
JEMBETAT
G A L L E R Y

Authentic African
Artifacts & Jewelry

Museum Quality Art

Tribal Masks
Wooden Bowls
Drums
Beads
Jewelry
Rugs
Dolls
Knives
Leather Boxes
Baskets
Tribal Statuary
Artifacts

Printed on recycled paper

(jĕm-bĕt-at)

a west african
word for replanting

10% of our profits fund
forestry and agriculture
projects in Senegal, West Africa.

Robert Ament
Proprietor

7 Schoen Place
Pittsford, New York
14534
1.800.688.6254
p/f 716.383.1420

CLIENT: The Jembetat Gallery

DESIGN FIRM: Zebra Design

ART DIRECTOR/DESIGNER/ILLUSTRATOR:
James L. Selak

SOFTWARE: Macromedia Freehand /
Quark XPress

PRINTING: Offset

126 W. LOCKWOOD AV. WEBSTER GROVES, MO 63119

S LEMAN

ARAM GAZANCHYAN (314)961-5979

ARCADE SH E REPAIR & TAILORING

TUESDAY-FRIDAY 9AM TO 5PM / SATURDAY 9AM TO 4PM

CLIENT: Arcade Shoe Repair

DESIGN FIRM: Bartels & Company

ART DIRECTOR: David Bartels

DESIGNER: Mary M. Moore

SOFTWARE: Adobe Illustrator / Quark XPress

PAPER STOCK: Dull 110 lb. cover

Blue Duck LLC

SCREEN PRINTING

3738 CHOUTEAU AV.
ST. LOUIS, MO 63110

BRIAN E. LANG

TEL FAX
772.6777 772.7830

CLIENT: Blue Duck Screen Printing

DESIGN FIRM: Bartels & Company

ART DIRECTOR: David Bartels

DESIGNER/ILLUSTRATOR: Ron Rodemacher

SOFTWARE: Adobe Illustrator

PAPER STOCK: Dull 110 lb. cover

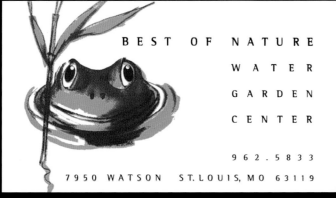

CLIENT: Best of Nature

DESIGN FIRM: Bartels & Company

ART DIRECTOR: David Bartels

DESIGNER/ILLUSTRATOR: Ron Rodemacher

SOFTWARE: Adobe Illustrator /
Adobe Photoshop

PAPER STOCK: Chromecoat 110 lb. cover

CLIENT: Campbell Fisher Design (CFD)

DESIGN FIRM: Campbell Fisher Design

ART DIRECTORS: Mike Campbell / Greg Fisher

DESIGNER: Paul Svancara

PAPER STOCK: Strobe Dull / 120 lb. cover

PRINTING: 2 over 2 PMS inks

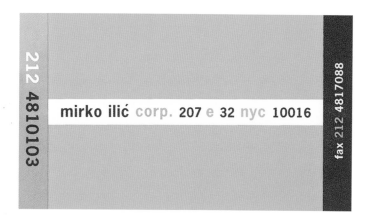

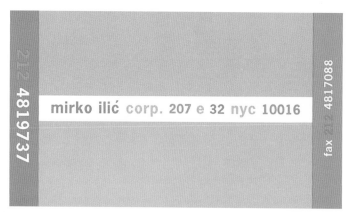

CLIENT: Mirko Ilić Corp.

DESIGN FIRM: Mirko Ilić Corp.

ART DIRECTOR/DESIGNER: Nicky Lindeman

SOFTWARE: Quark XPress

PAPER STOCK: Cougar

architect

doris guerrero, aia | 511 Leavenworth Street #101
San Francisco, CA 94109 | Telephone (415) 572 - 3716

orbitgirl@earthlink.net

architect

doris guerrero, aia | 511 Leavenworth Street #101
San Francisco, CA 94109 | Telephone (415) 572 - 3716

orbitgirl@earthlink.net

CLIENT: Doris Guerrero, Architect

DESIGN FIRM: Chris Rooney Illustration/Design

ART DIRECTOR/DESIGNER: Chris Rooney

SOFTWARE: Adobe Illustrator

PAPER STOCK: Cromatica Mango /
Absinthe 27 lb. /
Beckett Super Smooth
Expression Radiance
130 lb. cover

"Down."

5873 Saratoga Road
Dubuque, Iowa 52002
Ph/Fx: 319.582.5834
thatsmydog@mwci.net

ROBIN MACFARLANE
Certified Trainer

**That's
My
Dog!** CERTIFIED PROFESSIONAL DOG TRAINING

CLIENT: That's My Dog!

DESIGN FIRM: Get Smart Design Co.

ART DIRECTOR: Tom Culbertson

DESIGNER: Jeff MacFarlane

SOFTWARE: Adobe Photoshop / Quark XPress

PAPER STOCK: Fox River Select

PRINTING: 4-color process

ACME COMMUNICATIONS, INC.

175 FIFTH AVENUE

NEW YORK, NEW YORK 10010

☎ 212 982-3565

Fax: 212 982-3415

e-mail: Acme USA@ AOL.Com

KIKI BOUCHER

CLIENT: Acme Communications, Inc.

DESIGN FIRM: Acme Communications, Inc.

ART DIRECTOR: Kiki Boucher

DESIGNER: Jon Livingston

SOFTWARE: Quark XPress

PAPER STOCK: Strathmore Ultimate White cover

PRINTING: 2 colors, offset

CLIENT: Andrew A. Bartolotta.

DESIGN FIRM: Max Communications

DESIGNER: Karen Gold

SOFTWARE: Quark XPress / Adobe Photoshop

PAPER STOCK: Starwhite Vicksburg

PRINTING: 3 PMS colors over 2 PMS colors

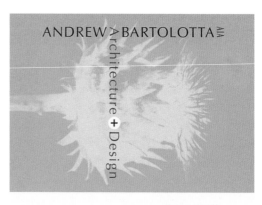

2 Ivy Knoll
Westport, CT 06880
t: 203.221.1278
f: 203.221.1271
ivyknoll@mindspring.com

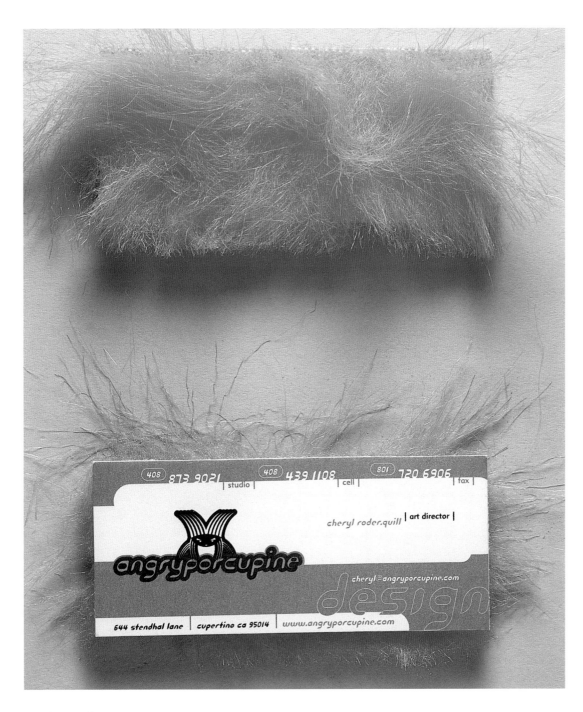

CLIENT: Angryporcupine

DESIGN FIRM: Angryporcupine

ART DIRECTOR/DESIGNER: Cheryl Roder-Quill

SOFTWARE: Adobe Illustrator

PAPER STOCK/MATERIALS: Wausau Bright White /
faux fur

PRINTING: 2 PMS colors and black

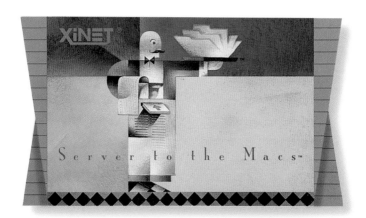

CLIENT: Xinet

DESIGN FIRM: Gee + Chung Design

ART DIRECTOR/DESIGNER: Earl Gee

ILLUSTRATOR: Robert Pastrana

SOFTWARE: Quark XPress / Adobe Illustrator

PAPER STOCK: Potlatch McCoy Gloss / 100 lb. cover

PRINTING: 4-color process offset lithography

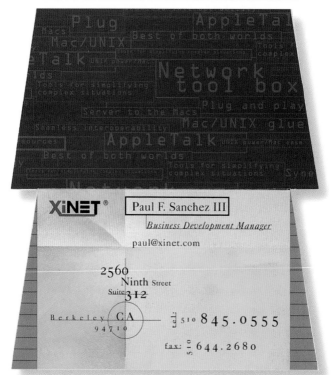

CLIENT: Nanocosm Technologies, Inc.

DESIGN FIRM: Gee + Chung Design

ART DIRECTORS/DESIGNERS: Earl Gee / Fani Chung

ILLUSTRATOR: Fani Chung

SOFTWARE: Quark XPress / Adobe Illustrator

PAPER STOCK: Kimdura White 74 lb.

PRINTING: 2 over 2 offset lithography

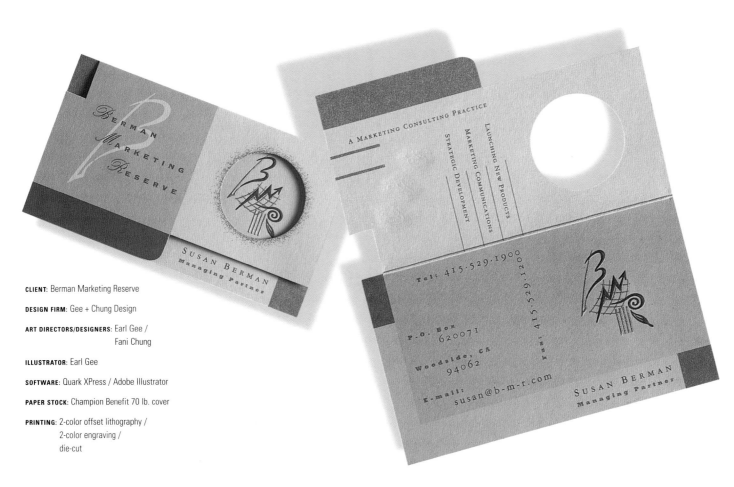

CLIENT: Berman Marketing Reserve

DESIGN FIRM: Gee + Chung Design

ART DIRECTORS/DESIGNERS: Earl Gee / Fani Chung

ILLUSTRATOR: Earl Gee

SOFTWARE: Quark XPress / Adobe Illustrator

PAPER STOCK: Champion Benefit 70 lb. cover

PRINTING: 2-color offset lithography / 2-color engraving / die-cut

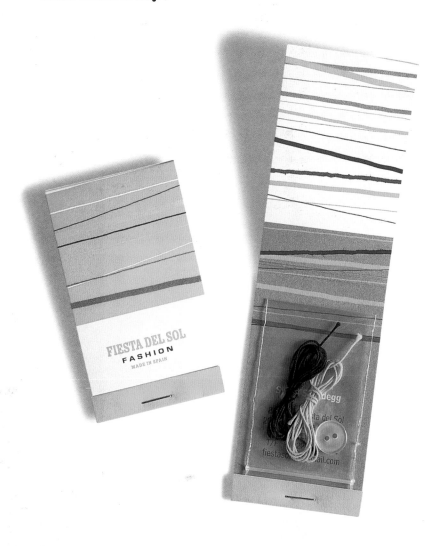

CLIENT: Fiesta Del Sol

DESIGN FIRM: Parenti Design Sarl

ART DIRECTOR: Lisa Parenti

DESIGNER: Karma Al Azmeh

SOFTWARE: Adobe Photoshop / Quark XPress

PAPER STOCK: Conqueror CX 22

PRINTING: 2 colors

CLIENT: Opera Live

DESIGN FIRM: Parenti Design Sarl

ART DIRECTOR: Lisa Parenti

DESIGNER/ILLUSTRATOR: Alessandra Marchetto

SOFTWARE: Adobe Illustrator / Quark XPress

PAPER STOCK: Conqueror CX 22

PRINTING: 2 colors

● **DOMINIQUE ASTRID LÉVY**
curator of collections and exhibitions

CLIENT: Start—Curator of Collections
 and Exhibitions

DESIGN FIRM: Parenti Design Sarl

ART DIRECTOR: Lisa Parenti

DESIGNER/ILLUSTRATOR: Alessandra Marchetto

SOFTWARE: Adobe Illustrator / Quark XPress

PAPER STOCK: Conqueror CX 22

PRINTING: 2 colors / die-cut

start

● ● **ART ADVISORY SERVICE**
COMMISSARIAT D'EXPOSITIONS
ET GESTION DE COLLECTIONS

DOMINIQUE ASTRID LÉVY SIMON STUDER
36, AV. CARDINAL-MERMILLOD CH-1227 GENÈVE
TÉL. 41 (22) 827 90 80 FAX 41 (22) 827 90 81
E-MAIL start.studer-levy@iprolink.ch

CLIENT: Zealous

DESIGN FIRM: JOED Design Inc.

ART DIRECTOR/DESIGNER: Edward Rebek

SOFTWARE: Macromedia Freehand

PAPER STOCK: Strathmore Writing

PRINTING: 2 over 2 letterpress with
 metallic inks

CLIENT: Beringer Blass—Benchmark

DESIGN FIRM: CPd-Chris Perks Design

SOFTWARE: Adobe Photoshop /
Adobe Illustrator

PAPER STOCK: White artboard 310 gsm /
Mattkote

CLIENT: Work, Inc.

DESIGN FIRM: Howalt Design Studio, Inc.

ART DIRECTORS: Paul Howalt / Cabell Harris

DESIGNER/ILLUSTRATOR: Paul Howalt

SOFTWARE: Macromedia Freehand

MATERIALS: Yupo Synthetic

PRINTING: 2 over 1 offset / laminated / die-cut

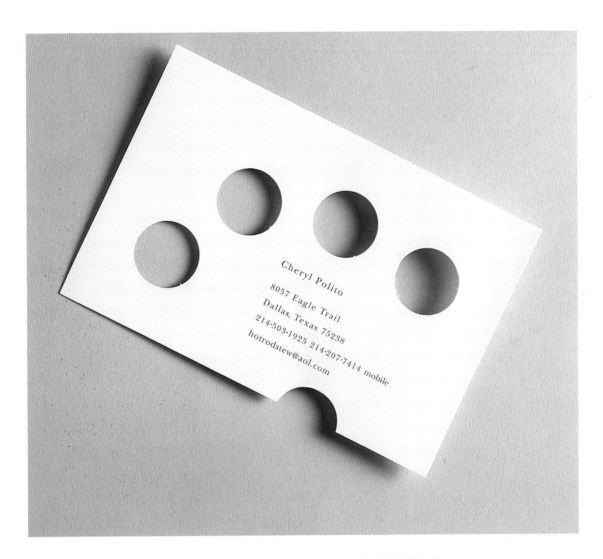

Cheryl Polito
8057 Eagle Trail
Dallas, Texas 75238
214·503·1925 214·207·7414 mobile
hotrodstew@aol.com

CLIENT: Cheryl Polito / Manicurist

DESIGN FIRM: Group Baronet

ART DIRECTOR/DESIGNER: Willie Baronet

CLIENT: Crosby Fashion & Style

DESIGN FIRM: Rullkötter AGD

ART DIRECTOR: Dirk Rullkötter

DESIGNERS: Dirk Rullkötter / Marco Rullkötter

SOFTWARE: Macromedia Freehand

PAPER STOCK: Strathmore Americana

PRINTING: 2 colors / offset

⸻⟶ Kerstin Struck
Eschstraße 39
32257 Bünde
Tel.: 0 52 23 / 58 03
Fax.:0 52 25 / 79 02 05

CLIENT: Dorf Café

DESIGN FIRM: Riggert Design

ART DIRECTOR/DESIGNER: Kurt Riggert

SOFTWARE: Adobe Photoshop

PAPER STOCK: Crown Vantage 250g

D O R F

C A F É

Dorfstraße 27
25826 St. Peter-Ording
Telefon 04863-3021
Inh.: Hella Cornils-Vorbeck

ERNST-HERMANN RUTH · FOTODESIGN
PRIMELWEG 24
D - 82538 GERETSRIED / MÜNCHEN
TEL 49 8171-96248
FAX 49 8171-96249
MOBIL 0171-5127372

CLIENT: Hermann Ruth Fotodesign

DESIGN FIRM: Riggert Design

ART DIRECTOR/DESIGNER: Kurt Riggert

SOFTWARE: Adobe Photoshop

PAPER STOCK: Crown Vantage 250g

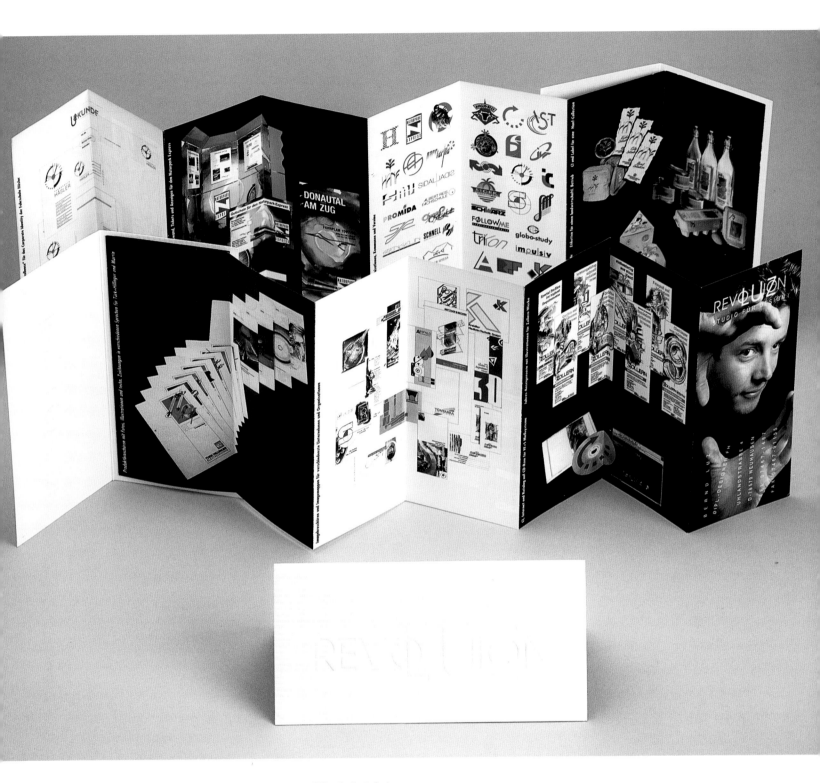

CLIENT: revoLUZion—Studio für Design

DESIGN FIRM: revoLUZion—Studio für Design

DESIGNER: Bernd Luz

SOFTWARE: Quark XPress / Adobe Photoshop /
Macromedia Freehand

Contributers

Acme Communications, Inc.
175 Fifth Avenue
New York, NY 10010
kikiacme@aol.com

AdamsMorioka
370 South Doheny Drive, No. 201
Beverly Hills, CA 90211
sean@adamsmorioka.com

Ads & Art
2715 Pennington Court N.W.
Rochester, MN 55901
vantassel.jeremy@adsart.com

ALR Design
3007 Park Avenue, #1
Richmond, VA 23221
www.alrdesign.com

Amoeba Corp.
49 Spadina Avenue, Studio 507
Toronto, ON M5V 2J1
Canada
zenboy@amoebacorp.com

Anderson Thomas Design
110 29th Avenue, North
Suite 100
Nashville, TN 37203
jay@andersonthomas.com

Andrew A. Bartolotta
Architecture + Design
2 Ivy Knoll
Westport, CT 06880
ivyknoll@mindspring.com

Angryporcupine
644 Stendal Lane
Cupertino, CA 95014
Cheryl@angryporcupine.com

Asbury Studios
2615 Amherst Road, #B-23
Middleton, WI 53562
asburystudios@yahoo.com

Atelier Tadeusz Piechura
Zgierska 124/140, M.168
Lodz 91-320
Poland
48-42-6544633

Bartels & Company
3284 Ivanhoe Avenue
St. Louis, MO 63139
bartels@primary.net

be.design
1323 Fourth Street
San Rafael, CA 94901
(415) 451-3530

Beyond Blond Design Group
2602 22nd Street
Santa Monica, CA 90405
michelle@beyondblond.com

Blackcoffee Design Inc.
840 Summer Street
Boston, MA 02127
mail@blackcoffeedesign.com

Black Rocket
Pier 33 South, 3rd Floor
San Francisco, CA 94111
mumford@blackrocket.com

Blok Design
822 Richmond Street W, Suite 301
Toronto, ON M6J 1C9
Canada
blocdesign@earthlink.net

Bluestone Creative Agency
neil@bluestone.co.uk

Braue Branding &
Corporate Design
Eiswerkestrasse 8
Bremerhaven, Bremen 27572
Germany
mail@brauedesign.com

brianfidler interactive
3418 East Elm Street
Phoenix, AZ 85018
interactive@brianfidler.com

Brown Design & Co.
408 Fore Street
Portland, ME 04101
mbrown@browndesign.net

Campbell Fisher Design
3333 East Camelback Road, #200
Phoenix, AZ 85018
mail@cfd2k.com

Carbone Smolan Agency
22 West 19th Street, 10th Floor
New York, NY 10011
leslies@carbonesmolan.com

Carnase Inc.
30 East 21st Street
New York, NY 10010
carnase@carnase.com

Chris Rooney
Illustration/Design
639 Castro Street
San Francisco, CA 94114
looneyrooney@mindspring.com

Christopher Palmer
7336 S. Blackstone Avenue
Chicago, IL 60619
(773) 684-3753

City of Moncton
655 Main Street
Moncton, NB E1C 1E8
Canada
jwheaton@nb.aibn.com

Colormetro
1070 Howard Street
San Francisco, CA 94103
colormetro@earthlink.net

CPd-Chris Perks Design
333 Flinders Lane, 2nd Floor
Melbourne, Victoria 3000
Australia
d.ohehir@cpdtotal.com.au.

Cross Colours Inc.
P.O. Box 412109
Craighall 2024
South Africa
cross@iafrica.com

Current, Inc.
887 W. Marietta Street,
Suite t-102
Atlanta, GA 30318
jsercer@currentsite.com

Custom Communications
P.O. Box 35388
Richmond, VA 23235-0388
Ljh@custom-communications.com

Damion Hickman Design
1801 Dove, #104
Newport Beach, CA 92660
damion@damionhickman.com

Design Center
15119 Minnetonka Blvd.
Minnetonka, MN 55345
jreger@design-center.com

Design Duo Inc.
1952 1st Avenue South, Studio 2
Seattle, WA 98134
www.designduoinc.com

Design Infinitum
9450 NW Engleman Street
Portland, OR 97229
dinfinitum@aol.com

Design 360°
1144 West Fulton Market
Chicago, IL 60607
scott@design360.net

Designbüro no. 804
Ronsdorfer Strasse 77a
Düsseldorf 40233
Germany
info@no804.de

Detroit Steam Engines Art & Design
306 Mulholland
Ann Arbor, MI 48103
jlg@squeakyporcupine.com

DGWB
217 N. Main Street, #200
Santa Ana, CA 92701
azappella@dgwb.com

Dick Chin Art Direction
218 Ontario Street
Toronto, ON M5A 2V5
Canada
dickchin@globalserve.net

Diesel Design
948 Illinois Street, Suite 108
San Francisco, CA 94107
www.dieseldesign.com

Dinnick & Howells
298 Markham Street
Toronto, ON M6J 2G6
Canada
angela@dinnickandhowells.com

Dotzero Design
8014 SW 6th Avenue
Portland, OR 97219
jonw@dotzerodesign.com

Douglas Oliver Design Office
2054 Broadway
Santa Monica, CA 90404
jspencer@dodola.com

Dunn and Rice Design, Inc.
16 North Goodman Street
Rochester, NY 14607
gregg @dunnandrice.com

Dynamo
5 Upper Ormond Quay
Dublin 7
Ireland
briann@dynamo.ie

Dynamo Art & Design
19 Broadway
Watertown, MA 02472
nw@dynamodesign.com

Dzine Wise Design Studio
2527 Marywood
Dubuque, IA 52001
mike@dzinewise.com

Eastern Edge Media Group, Inc.
47 W. Stewart Avenue
Lansdowne, PA 19050
mj@eemg.com

Edmunds Jones Design P/L
83 Mount Street
Suite 1001, 10th Level
North Sydney, NSW 2060
Australia
ejays@edmundsjones.com.au

Ego Communications
27 Cambertin
Cantley, PQ J8V 2V8
Canada
egocom@egocom.com

Elixir Design
2134 Van Ness Avenue
San Francisco, CA 94109
cdw@elixirdesign.com

Elizabeth Resnick Design
126 Payson Road
Chestnut Hill, MA 02467
ElizRes@aol.com

Elements, LLC
28 Summit Road
Hamden, CT 06514
elementsaw@aol.com

Emery Vincent Design
80 Market Street
Southbank, VIC 3006
Australia
Garry.emery@evd.com.au

Emma Wilson Design Company
500 Aurora Avenue N
Seattle, WA 98109
emma@emmadesignco.com

Enki NY
636 Broadway, 707
New York, NY 10012
lana@enkiny.com

Equus Design Consultants P/L
8 B Murray Terrace
Singapore 079522
alex@equus_design.com

F. Wartenberg Photography
Leverkusenstr.25
Hamburg 22761
Germany
frank@frank-wartenberg.com

Fabrice Praeger
54 Bis Rue de L'Ermitage
Paris 75020
France
01 40-33-17-00

Fishhead Design
1200 East Woodhurst, Building V
Springfield, MO 65804
elvis@marlin-thing.com

Formgefühl
Suttner Str. 8
Hamburg
Germany
marius@formgefuehl.de

44 Phases
844 Wilshire Blvd., 5th Floor
Beverly Hills, CA 90211
Daniel@44phases.com

Free-Range Chicken Ranch
1053 Lincoln Avenue
San Jose, CA 95125
toni@freerangechickenranch.com

Fuel Design
727 W. Hargett Street, Suite 101
Raleigh, NC 27603
stg@fueldesigngroup.com

FunkyFoto
5036 Grimm Drive
Alexandria, VA 22304
Johnny@grafik.com

Gardner Design
3204 E. Douglas
Wichita, KS 67208
travis@gardnerdesign.net

Gee + Chung Design
38 Bryant Street, Suite 100
San Francisco, CA 94105
earl@geechungdesign.com

Get Smart Design Co.
899 Jackson Street
Dubuque, IA 52001
getsmartjeff@mwci.net

Gott Folk McCann-Erickson
Sidumuli 24
Reykjavik 108
Iceland
einar@gottfolk.is

GraphicType Services
24 Sherwood Lane
Nutley, NJ 07110
www.graphictype.com

Greteman Group
1425 E. Douglas, Suite 200
Wichita, KS 67211
www.gretemangroup.com

Group Baronet
2200 N. Lamar, #201
Dallas, TX 75202
bronson@groupbaronet.com

High Noon Studios
941 Elysium Blvd.
Mt. Dora, FL 32757
hnstudios@aol.com

Hollis
344 7th Avenue
San Diego, CA 92101
markb@hollisdesign.com

Hornall Anderson Design Works, Inc.
1008 Western Avenue, Suite 600
Seattle, WA 98104
c_arbini@hadw.com

Howalt Design Studio, Inc.
527 W. Scott Avenue
Gilbert, AZ 85233
howalt@qwest.net

[i]e design, Los Angeles
1600 Rosecrans Avenue, 6B/200
Manhattan Beach, CA 90266
mail@iedesign.net

i.e. design, inc.
150 W. 25th Street, #404
New York, NY 10001
nicole@ie-design.com

Inkahoots
239 Boundary Street
West End, Queensland 4101
Australia
www.inkahoots.com.au

Jeanne F. Goodman
1334 Botetourt Gardens
Norfolk, VA 23517
JGood51@aol.com

Jim Moon Designs
182 Oakdale Avenue
Mill Valley, CA 94941
jmoondes@aol.com

JOED Design Inc.
533 South Division Street
Elmhurst, IL 60126
erebek@joeddesign.com

John Robshaw Textiles
245 West 29th Street
#1101
New York, NY 10001
JTRobshaw@aol.com

Kan & Lau Design Consultants
28/F Great Smart Tower
830 Wanchai Road
Hong Kong
kan@kanandlau.com

Kelman Design
207-1009 Howay Street
New Westminster, BC V3M 6RI
Canada
kelmandesign@yahoo.com

Kismet Design Group, LLC
1560 Cleveland Road
Glendale, CA 91202
stacy@kismetdg.com

Kontrapunkt
Parmova 20
Ljubljana 7000
Slovenia
Eduard.cehovin@siol.net

**Kristy A. Kutch Colored Pencil
Workshops**
11555 W. Earl Road
Michigan City, In 46360
kakutch@niia.net

KROG
Krakovski Nasip 22
1000 Ljubljana
Slovenia
Edi.berk@krog.si

Landesberg Design Associates
1219 Bingham Street
Pittsburgh, PA 15203
debrat@designlande.com

Laurey Robin Bennett Design
9725 Saturn Street
Los Angeles, CA 90035
laurey@mindspring.com

Likovni Studio D.O.O.
Dekanici 42, Kerestinec
Sveta Nedjelja 10431
Croatia
list@list.hr

Lima Design
215 Hanover Street
Boston, MA 02113
beans@limadesign.com

Liska + Associates, Inc.
515 North State Street, 23rd Floor
Chicago, IL 60610
agray@liska.com

Lowercase, Inc.
213 W. Institute Place, 311
Chicago, IL 60610
sdvorak@lowercase.com

LPG Design
410 East 37th Street North
Wichita, KS 67219-3556
dcommer@lpgdesign.com

MA&A—Mário Aurélio & Associados
Rua Eng. Ezequiel de Campos 159 1°
Porto L100-231
Portugal
Mario@maadesign.com

Manx Kommunikations Design
Hammer Strasse 156
Essen (Ruhr) 45257
Germany
howe@manx.de

**Marketing and Communication
Strategies, Inc.**
2218 First Avenue NE
Cedar Rapids, IA 52402
eman@mcshome.com

Mirage Design
840 Summer Street
Boston, MA 02127
miragedesign@earthlink.net

Mirko Ilić Corp.
207 E. 32nd Street
New York, NY 10016
(212) 481-9737

missHill Design
3523 Hutchison, #2
Montreal, PQ H2X 2G9
Canada
shawstria@hotmail.com

Moonlit Creative Group
1523 Napier Terrace
Lawrenceville, GA 30044
ceggers@moonlitcreative.com

Mortensen Design
416 Bush Street
Mountain View, CA 94041
Gmort@mortdes.com

Musser
508 Chestnut Street
Columbia, PA 17512
musser@musser.cc

Nassar Design
11 Park Street
Brookline, MA 02446
nnassar@shore.net

Nichols Graphic Design
80 Eighth Avenue, #900
New York, NY 10011
NGD80@aol.com

9Volt Visuals
231 Euclid Avenue
Long Beach, CA 90803
bjune@9voltvisuals.com

Oakley Design Studios
921 SW Morrison Street, #540
Portland, OR 97205
oakleyds@oakleydesign.com

On The Edge Design
1601 Dove Street, #294
Newport Beach, CA 92660
gina@ontheedgedesign.com

Orbit Integrated
722 Yorklyn Road, Suite 150
Hockessin, DE 19707
www.theorbit.com

Palazzolo Design Studio
6410 Knapp
Ada, MI 49301
becky@palazzolodesign.com

Parenti Design Sarl
36 Avenue Cardinal-Mermillod
Carouge, Geneva 1227
Switzerland
info@parentidesign.com

Pierce Design
1945 East Ridge Road, Suite 22
Rochester, NY 104622
pierce@frontiernet.net

Pinkhaus Design
2424 South Dixie Highway, Suite 201
Miami, FL 33133
Janice.Q@pinkhaus.com

Piscatello Design Centre
355 Seventh Avenue, Suite 304
New York, NY 10001
info@piscatello.com

Planaria
2318 King Place NW
Washington, DC 20007
nick@planariainc.com

Planet Propaganda
605 Williamson Street
Madison, WI 53703
connie@planetpropaganda.com

Porto + Martinez Design Studio
Rua Capistrano de Abreu 44/101
Rio de Janeiro, RJ 22271-000
Brazil
design@portomartinez.com

Q30 Design Inc.
489 King Street W, Suite 400
Toronto, ON M5V 1K4
Canada
pscott@q30design.com

R2 Design
Praceta D Nuno Álvares Pereira 20 5 FQ
Matosinhos 4450
Portugal
r2design@rdois.com

R & M Associati Grafici
Traversa Del Pescatore 3
Gastellammare Di Stabia
Naples 80053
Italy
rmassociati@tin.it

Red Bee® Studio
77 Lyons Plain Road
Weston, CT 06883
carole@redbeestudio.com

Refinery Design Co.
2001 Alta Vista Street
Dubuque, IA 52001
refinery@dubuque.net

Reich Paper
7518 Third Avenue
Booklyn, NY 11209
(800) 230-3674
duke@reichpaper.com

revoLUZion–Studio für Design
Uhland Strasse 4
Neuhausen ob Eck 78579
Germany
info@revoluzion.de

Riggert Design
Wegzoll 53
Hamburg D-22393
Germany
riggertk@aol.com

Romanson Design Group
11321 Iowa Avenue, Suite 11
Los Angeles, CA 90025
roman@ucla.edu

Rome & Gold Ltd.
P.O. Box 66438
Albuquerque, NM 87193
romegold@integrity.com

Rule 29
25 South Grove Avenue, Suite 301
Elgin, IL 60120
justin@rule29.com

Rullkötter AGD
Kleines Heenfeld 19
Kirchlengern, NRW 32278
Germany
info@rullkoetter.de

Sackett Design Associates
2103 Scott Street
San Francisco, CA 94115
elisalindenmayer@sackettdesign.com

Sara Nelson Design, Ltd.
P.O. Box 2010
Pasco, WA 99302
saradesign@att.net

Satellite Graphics
180 Orchard Road
Orange, CT 06477
satellitestudio@netscape.net

Sayles Graphic Design
3701 Beaver Avenue
Des Moines, IA 50310
sayles@saylesdesign.com

Segura Inc.
1110 N. Milwaukee Avenue
Chicago, IL 60622
carlos@segura-inc.com

Sevell & Sevell, Inc.
240 N. 5th Street, Suite 200
Columbus, OH 43215
sevell@sevell.com

Shane Lewis Design, Inc.
4445 Hidden Shadow Drive
Tampa, FL 33614
shane@shanelewisdesign.com

Smith Design Associates
205 Thomas Street
P.O. Box 8278
Glen Ridge, NJ 07028
assoc@smithdesign.com

So Design Pty Ltd.
76 Punt Road
Windsor, VIC 3181
Australia
sodesign@ozemail.com.au

Studio GT & P
Via Ariosto, 5
06034 Foligno (PG)
Italy
www.tobanelli.it

Studiomoon
60 Federal Street, No. 510
San Francisco, CA 94107
sarvar@studiomoon.com

Summa
Roger De Lluria 124, Planta 8
Barcelona 08037
Spain
wmarnich@summa.es

Sunja Park Design
2116 Roselin Place
Los Angeles, CA 90039
sunjap@earthlink.net

Sussner Design Company
212 3rd Avenue N., #505
Minneapolis, MN 55401
derek@sussner.com

TXS Industrial Design, Inc
1761 International Parkway, #135
Richardson, TX 75081
john@txsdesign.com

Tennis, anyone?
Viktoriagatan 3
Gothenburg
Sweden
Linda@tennisanyone.se

Terrapin Graphics
991 Avenue Road
Toronto, ON M5P 2K9
james@terrapin-graphics.com

Tharp Did It
50 University Avenue, Suite 21
Los Gatos, CA 95030
(408) 354-6726

The Post Press
16 Thompson Lane
Newark, DE 19711-3220
Martha@udel.edu

The Riordon Design Group Inc.
131 George Street
Oakville, ON L6J 3B9
Canada
ric@riordondesign.com

Thirst
132 W. Station Street
Barrington, IL 60010
ewa@3st2.com

Tim Kenney Design Partners
3 Bethesda Metro Center, Suite 63
Bethesda, MD 20814
tim@tkdp.com

Toolbox
1721 Connecticut Avenue, NW
Washington, DC 20004
toolboxdc@aol.com

Turner and Associates
577 Second Street, Studio 204
San Francisco, CA 94107
phil@turnersf.com

2fold Creative
222 A North Main Street
Edwardsville, IL 62025
emma@2foldcreative.com

Vaughn Wedeen Creative
407 Rio Grand NW
Albuquerque, NM 87104
adewis@vwc.com

Velocity Advertising
306 Dartmouth Street
Boston, MA 02116
jennifer@velocityadvertising.com

Viva Dolan Communications & Design
99 Crown's Lane, Suite 500
Toronto, ON M5R 3P4
Canada
frank@vivadolan.com

Wages Design
887 West Marietta Street, Studio S-111
Atlanta, GA 30318
diane@wagesdesign.com

Widmeyer Design
911 Western Avenue, #523
Seattle, WA 98104
sevenson@widmeyerdesign.com

Winking Owl Studios
7065 Collins Pt. Road
Cumming, GA 30041
winkingowl@mindspring.com

X Design Compny
910-16th Street, #805
Denver, Co 80202
alexv@xdesignco.com

Xtremities Design
557 Roy Street, Suite 150
Seattle, WA 98109
cindy@xtremities.com

You Send Me
29 Patten Parkway
Chattanooga, TN 37402
(423) 267-8683

Zebra Design
5 Beatrice Cove
Fairport, NY 14450
zebrades@frontiernet.net

Zenvironments
51 Hillside Street., Apt. 2
Roxbury, MA 02120
somobo@hotmail.com

ZGraphics, Ltd.
322 North River Street
East Dundee, IL 60118
info@zgraphics.com

About the Author

Cheryl Dangel Cullen is a marketing and graphic design consultant who writes for several major graphic design publications. She is the author of a number of books, including *The Best of Annual Report Design; Large Graphics; Small Graphics; The Best of Brochure Design 6; Then is Now;* and *Promotion Design That Works,* all from Rockport Publishers. She lives outside Chicago.